NEWARK

THROUGH TIME

CONNIE L. RUTTER AND
SONDRA BROCKWAY GARTNER

AMERICA
THROUGH TIME®
ADDING COLOR TO AMERICAN HISTORY

AMERICA THROUGH TIME is an imprint of Fonthill Media LLC

Fonthill Media LLC
www.fonthillmedia.com
office@fonthillmedia.com

First published 2015

ISBN 978-1-63500-016-0

Typeset in Mrs Eaves XL Serif Narrow
Printed and bound in England

Connect with us:
 www.twitter.com/usathroughtime
 www.facebook.com/AmericaThroughTime

AMERICA THROUGH TIME® is a registered trademark of Fonthill Media LLC

CONTENTS

Acknowledgements
and Dedications

Our special thanks go to the Licking County Genealogical Society, the Licking County Historical Society, The Works Museum and to Daniel Fleming and the Licking County Public Library for the use of photographs and research material. The community owes them a great deal of gratitude for their sincere preservation efforts they demonstrate for this amazing town.

We also wish to thank Virginia Beach, Marie Gartner, Walter Hinger, Terre Matthews, Terry Mooney, David Phillips, Rebecca Dean Randall, Susan Reid, Erin Rutter, and Marilyn Stocker for the use of additional photographs and research material.

Unless otherwise noted all photographs are from the authors' collections and all new photographs were taken by author Sondra Brockway Gartner.

And finally we would like to dedicate this book to our children and grandchildren. Our love for them is immeasurable.

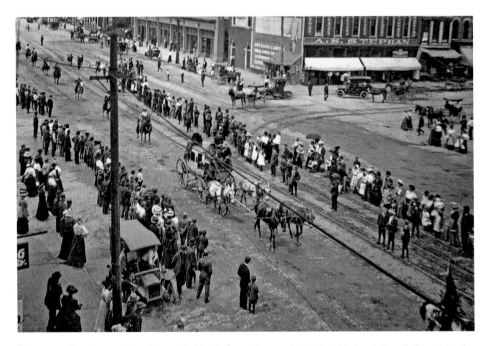

PARADE: Gentlemen in suits and ladies in long dresses line West Main at Fourth Street in the early 1900s to watch a stage coach and riders on horseback move toward the courthouse. The A. S. Stephan Department Store can be seen on the corner.

INTRODUCTION

Newark – the county seat of Licking County – sits geographically near the center of Ohio. The 2010 census puts the population at 47,573. Two thousand years ago Newark was a wilderness and home to the Hopewell Indian civilization. The reason for their disappearance is unknown; only the large earthen mounds and relics left behind give evidence of their cultural, behavioral, and religious existence. A large portion of these mounds, known as the Newark Earthworks, feature both octagonal and circular mounds and was designated a National Historic Landmark. It is under consideration as a possible UNESCO World Heritage Site.

In 1751, Christopher Gist, two of General George Washington's brothers, and some prominent Virginians explored the area for the Ohio Company of Virginia. In early 1802, William Schenck, G. W. Bernat, and John Cummins came from New Jersey to inspect a section of their 4,000 acres of military land. After surveying and plotting a settlement near a fork of the Licking River, they called it "New Ark" after Schenck's home town. Later an alteration was made to the spelling of the name.

After the digging of the Ohio Canal in 1825 – just a block south of the public square – the town grew rapidly. Taverns, bakeries, and flour mills sprang up overnight on the banks. Farmers arrived with produce, meat, grain, and livestock for shipment to other parts of the country. Shops, hotels, and professionals opened businesses to accommodate the influx of visitors. The busiest and most dangerous district was called "Gingerbread Row" where large amounts of gingerbread were served with cheap wine, hard cider, rum, birch beer, and rot-gut whiskey. This area became a haven for ruffians, drifters, canalers, and criminals.

For twenty-odd years, canal transportation ruled. But by 1852 the railroads had arrived. With a faster transportation system and a more efficient way of distributing goods, passenger trains became the preferential mode of travel for influential people on their journeys to Newark. Over the years eight different US Presidents, and prominent senators and generals, made stops at the local depots. The canal boats were no longer functioning by the 1890s and the waters were drained, the "Big-Dig" filled in, and the canal was all but forgotten.

With the arrival of the industrial age the city became a working man's nucleus for job hunters. The demand for labor brought men from Europe seeking work in the local greenhouses, on the railroad lines, and in the factories. It was commonplace for men and their families from England, Italy, or Germany to settle in neighborhoods close to

the downtown area. There have been a wide variety of items manufactured in Newark during the last 200 years including beer, cigars, glassware, automobiles, and golf clubs. The Wehrle Stove Factory employed 3,000 workers and was the largest factory of its kind in the world.

As with cities everywhere, not all has been idyllic. People have transgressed and events have occurred that have brought heartbreak to their families and shame to our town. Newark was once described as a lawless town. One early publication declared: "The town has begun to acquire a reputation as a 'red light' town with gamblers, thieves, and scarlet women. Law is laughed at and vice can walk unveiled." In the late nineteenth century, with over eighty saloons and a beer bottle factory employing over 2,000 workers, alcohol was vital to the city's economy.

But July 8, 1910 has been described as "the darkest day in Newark's history." That's when Carl M. Etherington, one of twenty state liquor "dry" detectives, was brought from Cleveland to close three speakeasies for illegally selling alcohol. After attempting to close the Last Chance Saloon he was trying to exit town in a hurry but was dragged from a street car and beaten. During the altercation William Howard, the owner and former police captain began striking Etherington on the head. In self-defense Etherington shot him in the chest. The detective was taken to the nearby jail and locked in a cell. When the news of Howard's death resonated through the town a mob of around 5,000 began forming. The vigilantes moved to the jail, broke down the door, dragged Etherington from his jail cell to the public square, and hung him from a telephone pole in front of thousands of men, women, and children. The sheriff and officers in charge refused to give the prisoner any protection. The former Marine was seventeen years old. Articles about the lynching appeared in *Cosmopolitan*, *The New York Times*, and the *New-York Tribune*.

In 2014 the organized Downtown Newark Association is working hard to "Re-Newark" the center of the city. Their results are paying off. Multiple businesses are stepping up to bring life back to the historic area.

Chapter One

Historic Downtown

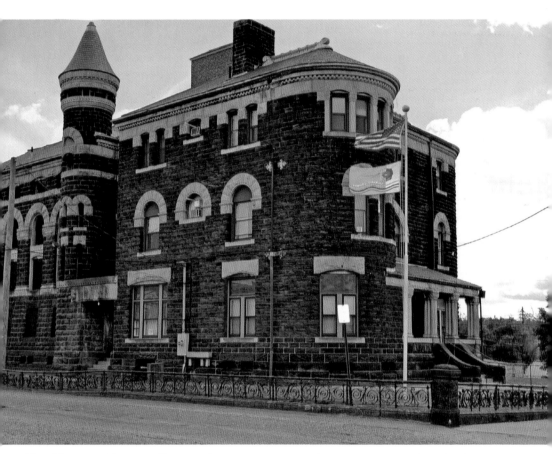

THE HISTORIC LICKING COUNTY JAIL: Designed by a Columbus architect in the Richardson Romanesque Style in 1889, the jail was built from pink sandstone at a cost of $120,000. Over time it became home to hundreds of evildoers including the Lewington Brothers – pegged the "22 Caliber Killers." In July 2014 the old jail became the star of television's extremely popular Travel Channel program "Ghost Adventurers." Searches for the haunting of lost souls revealed the jail has several.

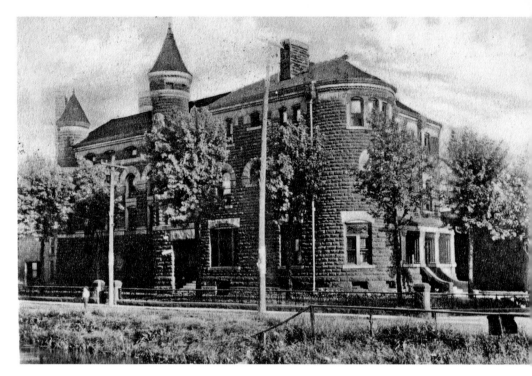

DECOMMISSIONED: Charges of some prisoners once held in the old jail have included murder, arson, auto theft, white slavery and of course drunk and disorderly. These have included both men and women. The imposing, blackened-stone structure closed its doors in 1987. It could no longer meet the safety standards imposed by state and local regulators. (*Courtesy of David Phillips.*)

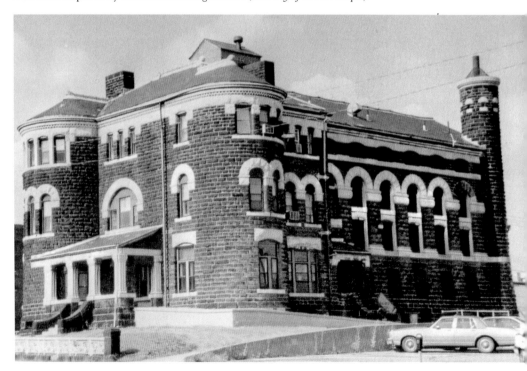

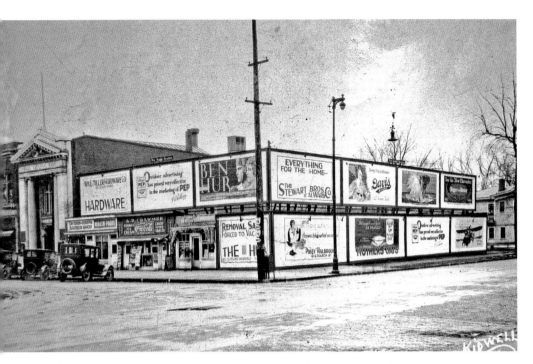

THE MIDLAND: The Theater opened in December 1928 but closed in 1978. After years of neglect the eyesore was bought by Dave Longaberger in 1992. He spent eight years and $8.5 million restoring the theater to its original beauty before presenting the property to the Newark Memorial Theater Association. Today the beautifully restored building is home once again to concerts, movies, and well-known performers. In front sits a bronze "Mark Twain" by sculptor Gary Lee Price.

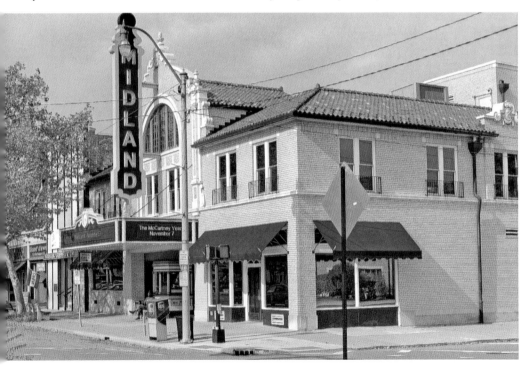

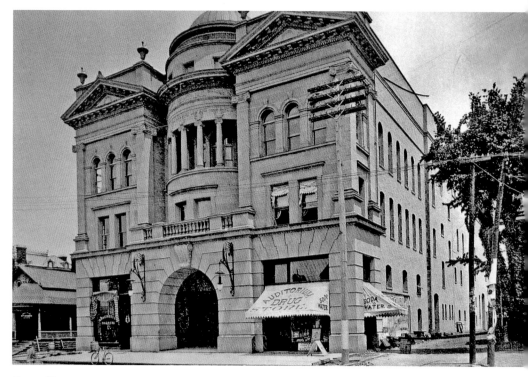

FROM THEATER TO PARK: The Soldiers and Sailors Memorial was also known as the Auditorium Theater. This imposing structure stood on land donated by the King estate. It was erected to honor veterans of the Civil War and was dedicated February 15, 1895. The victim of several fires, the building was demolished and the site now is home to Foundation Park, featuring bronze statues that include "Playmates with Tommy" by L'Deane Trueblood and "Patriots" by Reed Jensen.

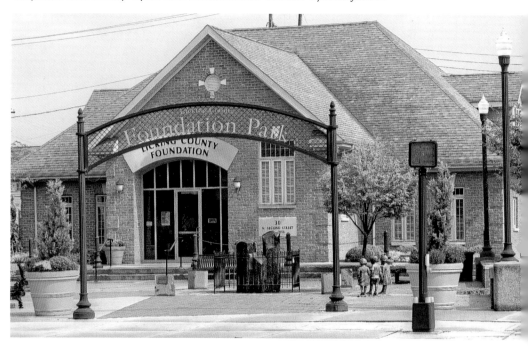

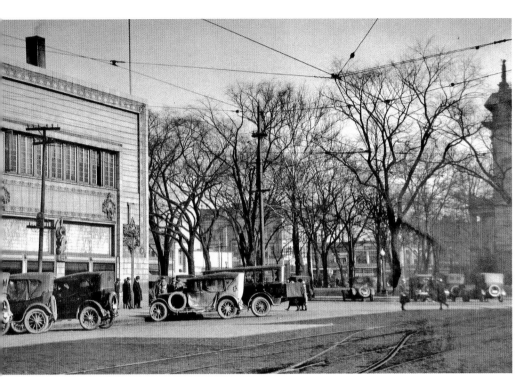

THE LOUIS SULLIVAN BUILDING: This amazing "terra cotta" building was designed by the famed Chicago architect and mentor to Frank Lloyd Wright. It is one of Sullivan's eight "Jewel Box Banks." It opened in 1914 as the Old Home Bank. The corner of the building has been removed, destroying the integrity of the design. In 2013 the structure was obtained by the Licking County Foundation, a philanthropic organization, who plans to restore and preserve this important historic landmark.

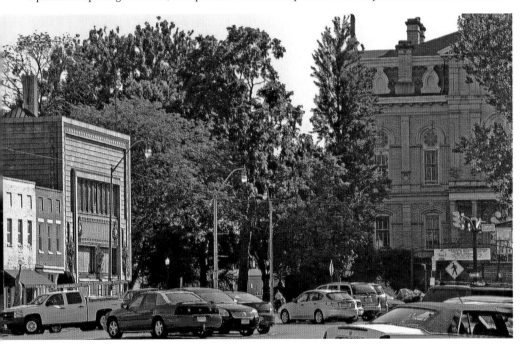

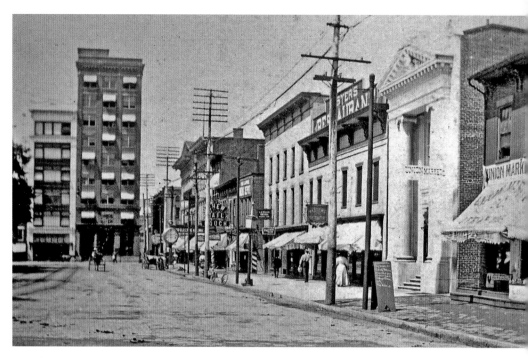

PARK NATIONAL BANK: The business was formed in 1908 by Alvin Lindorf, Augustus Wyeth, and William Gard. The doors opened in this Italian Renaissance-inspired building on the north side of the Courthouse Square in July 1909. Now a leader in the financial field the bank serves customers in many cities and states. With the need for more space and larger offices, the company moved part of their operation to the North Third Tower in 2014.

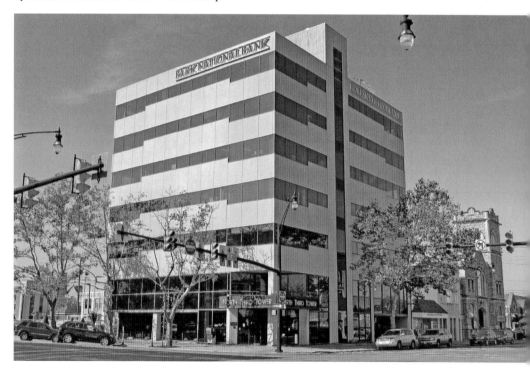

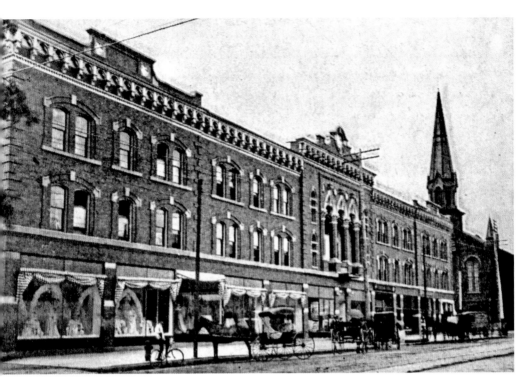

UNION BLOCK: Established in 1903 this Gothic Revival structure housed the Powers-Miller Department Store. On a Sunday morning in December of that year the store burned to the ground. In 1904 the building was rebuilt identical to the original design. By 2013 most of the building had been vacated. In 2014 it was obtained by Tom Atha, a local businessman, who plans to restore the building with loft apartments and retail shops. He hopes to recreate the original Crystal Ballroom.

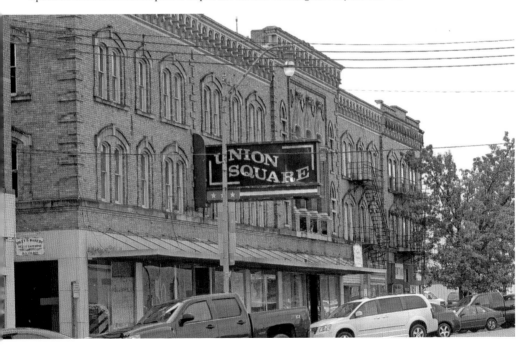

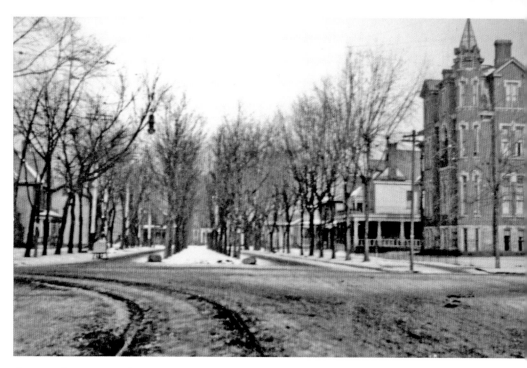

ON THE CORNER OF CHURCH AND SECOND STREETS: Gibson Atherton, mayor, congressman, and Ohio Supreme Court Judge, designed and built his four-storied residence after a Washington, DC, home in the 1860s. The home was known as the "Castle." In the 1880s it was home to James Lingafelter, a banker who brought an entertainment resort to the old fairgrounds and named it Idlewild Park. The house was demolished in 1952. It is the site of a new Hilton DoubleTree Hotel in 2014.

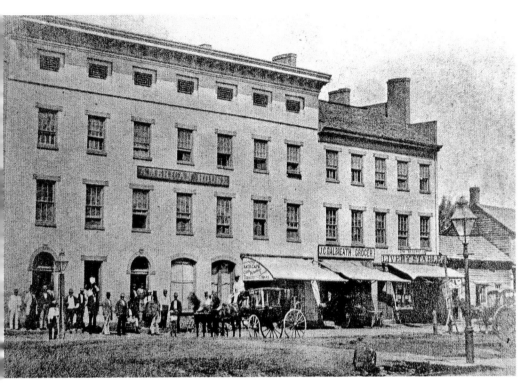

CHANGES OVER THE CENTURIES: The American House was also known as the Hotel Fulton and Doty House. In 1867 the inn and stagecoach stop sat next to a three-story brick building called Pataskala Hall and was the principal hostelry in Newark. In the 1960s the S. S. Kresge Company occupied the space and in 2014 the Buckeye Winery calls it home. Here customers can bottle their own wine and apply customized labels for special occasions.

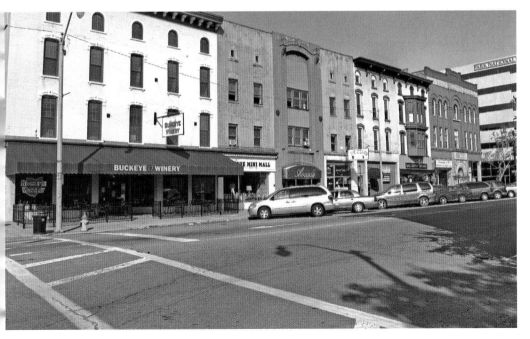

CITY HALL – THEN AND NOW: At the corner of West Main and Fourth Streets, the old building sat next to the Central Fire Station in the early 1900s. Around 1908 a market place with an upper floor public hall was located on the spot. The current City Municipal Building was erected on the same site in 1967 at a cost of $1,500,000. Ultra-modern for the day, the building now seems out of character with the surrounding architecture of the 1800s.

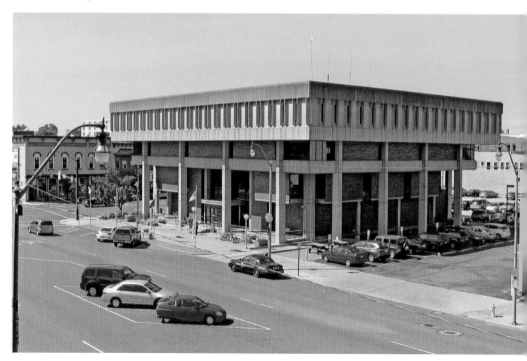

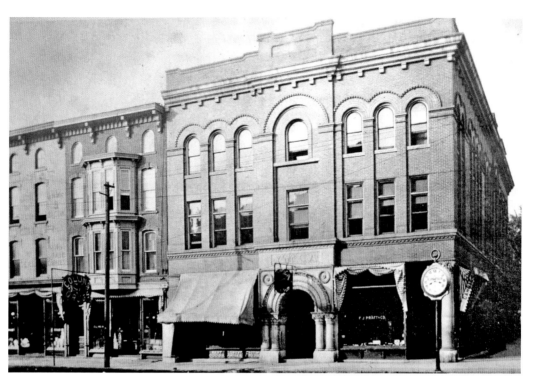

YMCA: In 1869 the Young Men's Christian Association was located on the third floor of the Hibbert and Schaus Building. It was a safe haven for young adult men. The organization then relocated to this corner of Church and North Third Streets. The corner is home to Daisy's Diner in 2014. A new larger facility of the "Y" is on West Church Street and is now a family-oriented organization offering a variety of programs for people of all ages.

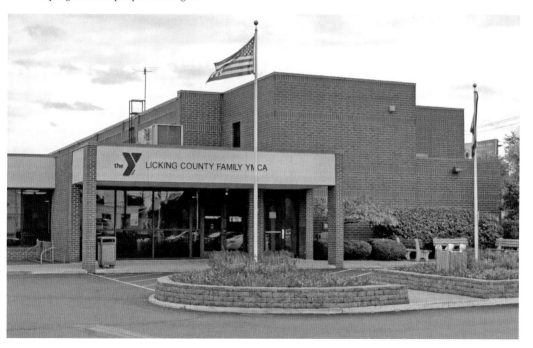

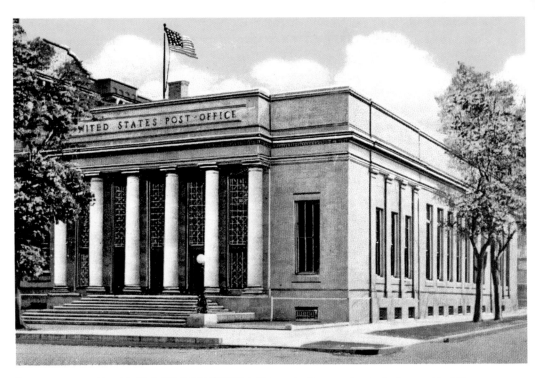

RESTORATION OF THE OLD US POST OFFICE: This majestic, neo-classical columned building was built in 1916 and operated for over fifty years before closing. It was later used as the Newark School System's administration office. The building was purchased at a sale in 2013 by a private buyer for $90,000. Renovations to the inside unveiled this amazing original glass skylight. It will now experience new life as the new Skylight Banquet Venue.

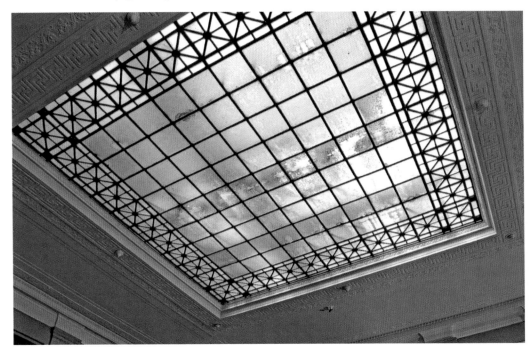

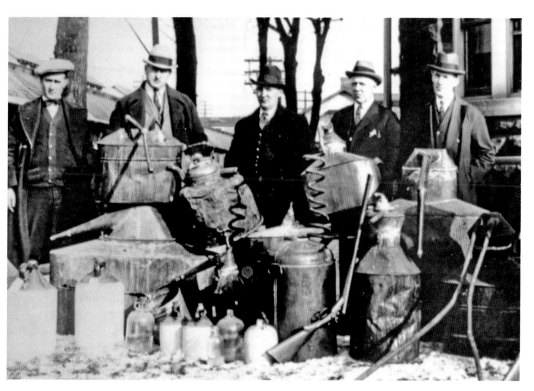

POLICE OFFICERS: In 1922 police officers pose in front of the old Licking County Jail with confiscated bootlegged, moonshine stills. The Newark Police Department was formed in 1835 with the mayor's appointment of its first officer, Marshal P. Morrison. A new state-of-the-art facility opened on South Fourth Street in 2005 where, a decade later, seventy-eight officers and twenty-three civilians work tirelessly to serve the community.

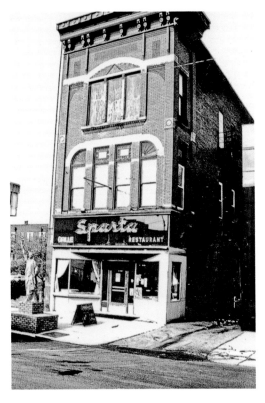

THE BISMARK BUILDING: Built around 1893 this three-storied building was home to the William Symons and Son Saloon. Customers could purchase guns, revolvers, and liquor. The building has been occupied by Symons Grocery, Elliot's Hardware, and the Sparta Restaurant and Candy Shop. The building, which stands isolated in 2014, was previously part of a typical Victorian commercial block. The current Sparta Restaurant and Coffee Shop is a social entrepreneurship business of Project Main Street helping the community.

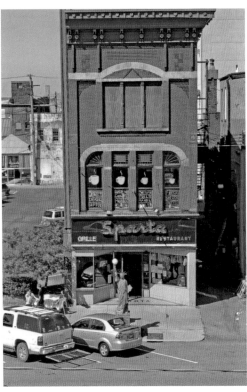

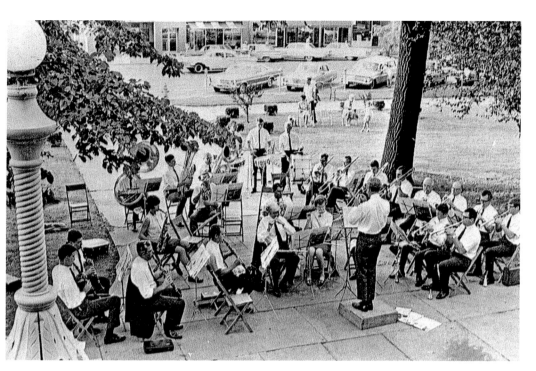

MUSIC IN THE AIR: The people of Newark love music and are enjoying the sounds of a local band performing in the 1960s on the courthouse lawn. In the autumn of 2014 the first Blue Grass Festival was held downtown with thousands attending and enjoying the bands playing in the streets and in private businesses around the Square. The band "Frosty Morning" played to the crowds on West Main Street.

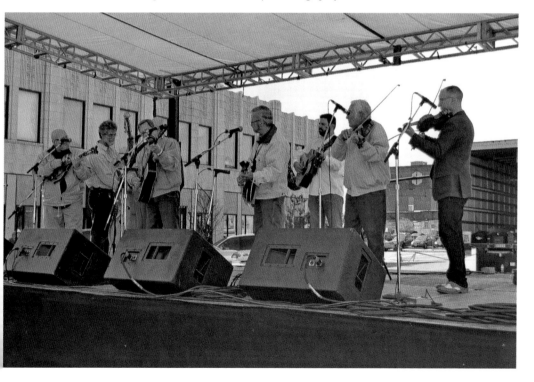

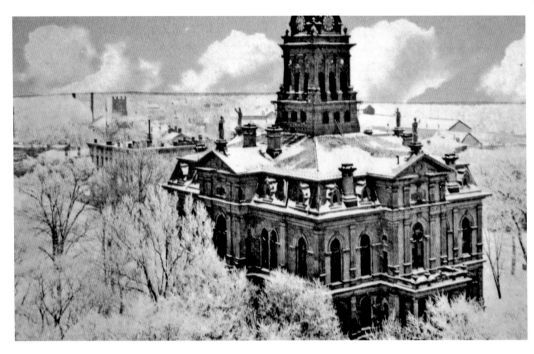

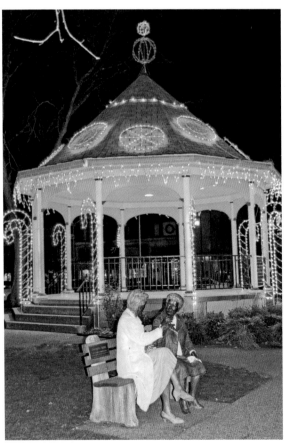

WINTER ON THE COURTHOUSE
SQUARE: On an old postcard dated
1911 the courthouse was covered with
snow. The background shows very
few buildings. Each year since 1948
the "Jewel of the County" has been
decked out in lights for the Christmas
season. The gazebo is also lit and was
photographed through the snowflakes
in 2013. Seated on a nearby bench are
two reminiscing bronze ladies, in a
sculpture by Seward Johnson depicting
his version of "Crossing Paths."

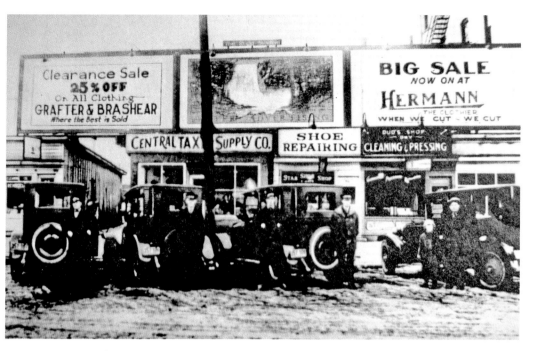

EAST MAIN STREET: On the south side of the street, around the 1920s, a row of small businesses occupied the location adjacent to the Warden Hotel. This included the Central Taxi Supply Company at 53 East Main Street. The drivers pose next to their taxis. By the late 1930s it had become the Yellow Cab Company. In the early twenty-first century the new brick Domestic Court building stands on the site. The old Warden Hotel has also disappeared.

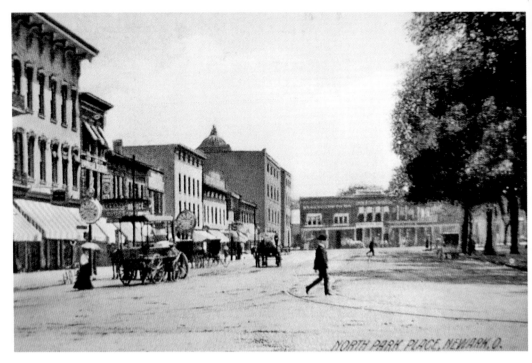

THE LANCING BLOCK: Also known as the Murray House, Tubbs House, and the Preston House this commercial block was built around 1859 in a typical high Victorian Italianate style. It's been home to a multitude of businesses. Veterans and soldiers once met here and stage coach stops were made on a regular basis. Over time the façade and interiors of the building have been modified. In 2015 offices and the Park Place Bistro occupy the space.

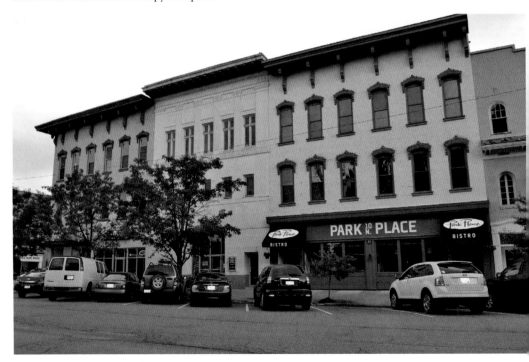

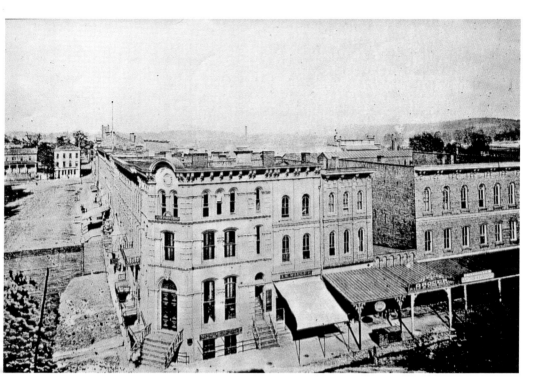

THE BRUNSWICK BUILDING: The gap in the streetscape of South Third Street was filled in around 1887. The building was built as a gentlemen's club but is vacant in 2014. It has been the Home Building Association, the Inter City Tea Company, Albyn's Nursery Seed Shop, plus an array of other businesses. It is just one of many old buildings around the downtown historic district to be reported as being haunted by ghosts.

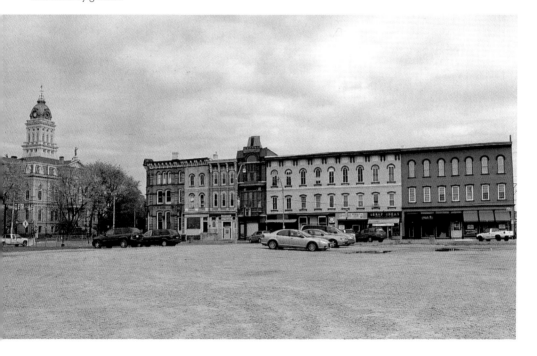

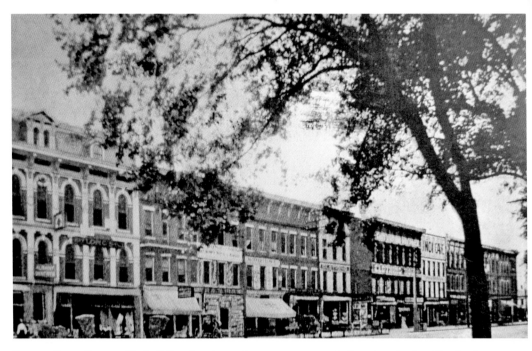

SOUTH PARK PLACE: The building that sits on the near east corner is thought to be the oldest business structure in town. In 1862 it held the Charles Ankele's Cigar Store. Little has changed to the streetscape with the exception of the new Wachtel and McAnally building. The fire of 1868 caused extreme damage to the western part of the block but the fire stopped at an alley that acted as a firebreak.

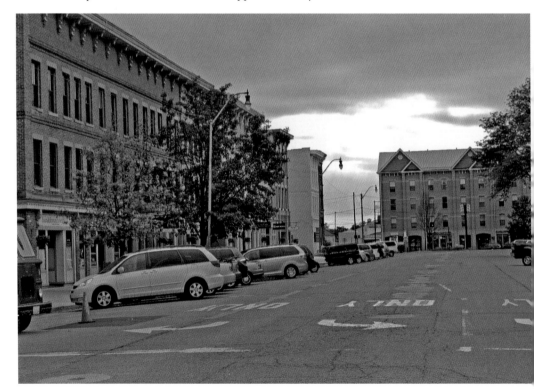

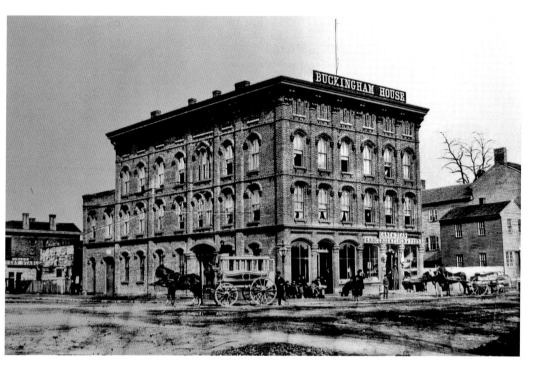

GONE ARE THE HOTELS: In the late 1860s the Buckingham House sat at the corner of South Second and East Main Streets. It was enlarged and renamed the Warden Hotel around 1886. It was renovated again and by 1903 it was a dynamic hotel with eighty rooms and the permanent home to many distinguished residents. The hotel finally closed in 1959. The building has since been demolished. Wendy's and the Licking County Municipal Building occupy the space in 2014.

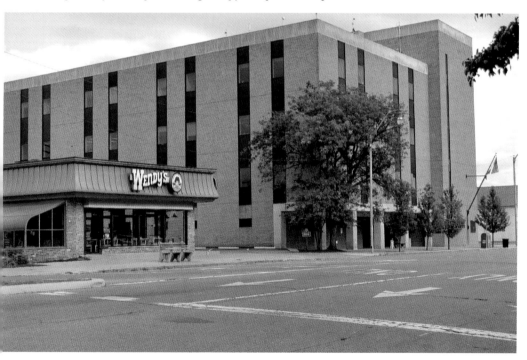

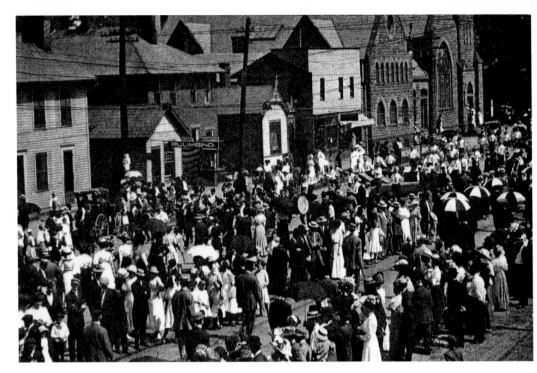

TRINITY EPISCOPAL CHURCH: The construction of the church began in 1890 on the north side of East Main Street. In 1896 Mrs. Martha Quincy donated a stained glass window in memory of Walter and Benjamin Quincy. She commissioned the Tiffany Glass and Decorating Company in New York City to do the design and installation. The window is sometimes called the "Ascension" window and measures 16'8" x 7'9" and was shipped to the church in 27,000 pieces.

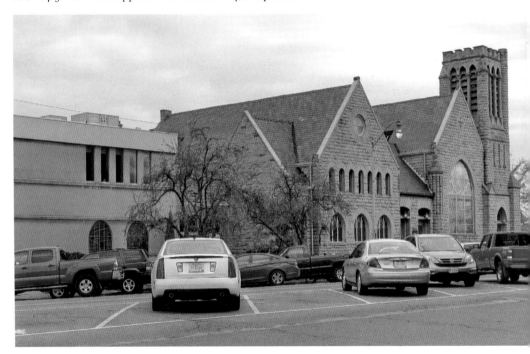

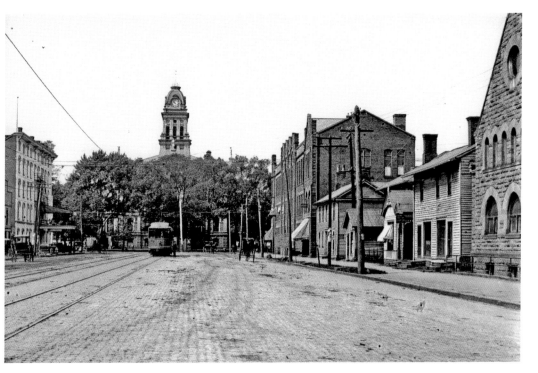

Is this Really the Same Street? With the exception of the courthouse and a glimpse of the corner of Trinity Episcopal Church, no resident living in the 1909 era could possibly recognize East Main Street as it appears in the 2014 photograph. The businesses have all disappeared and new ones were erected in their places. Even the street car and horse and buggy are no longer seen on this busy corridor.

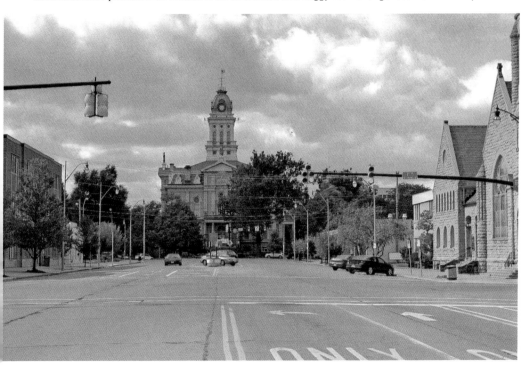

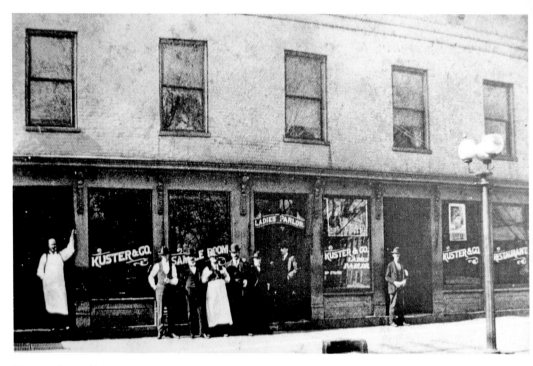

NORTH PARK PLACE: In the late 1800s Joseph Kuster's Diner featured a sixty-foot extended lunch counter and was the most popular spot on the Square to get a bite to eat. They served hundreds of meals a day to hungry and happy customers. In 2014 the façade of the building was renovated and now this beautiful building is home for the new owners of the Palumbo's Italian Market, the River Road Coffeehouse, and Linnet's Flowers on the Square.

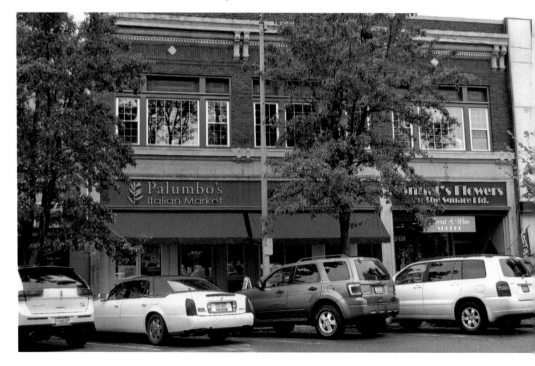

CHAPTER TWO

BUSINESSES AND INDUSTRY

NEWARK WAS HOME TO A GLASSWARE FACTORY: In 1893 Augustus Heisey bought the Penny farm on Oakwood Avenue close to the Pennsylvania Railroad line and built a small glassware factory. His beautiful pressed and cut glassware was sold to railways, hotels, and department stores. The "Diamond H" trademark was issued in 1901. The pressed glass, in many styles and colors, mimicked elegant cut glass but was more affordable for everyday use. The production of the fine tableware ended in 1957.

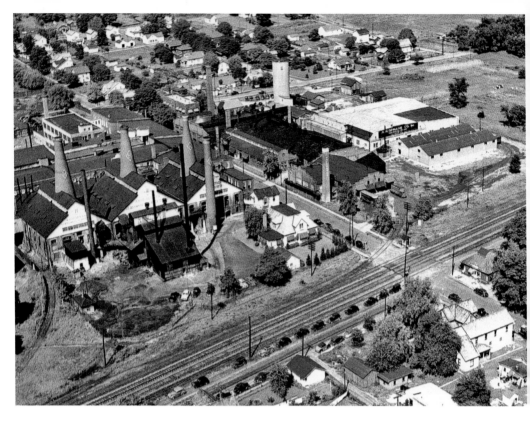

SEEN ONLY IN A MUSEUM: In 1973 the 1831 Greek revival home of Samuel D. King was moved to Veterans Park and restored. It houses the Heisey Collectors of America Museum in 2014. The museum offers collectors and visitors a chance to see original pieces in a beautiful home setting. The gift shop also features re-issued pieces made from the original Heisey molds.

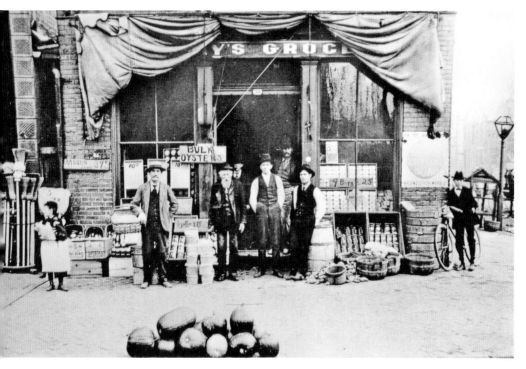

MURPHY'S MARKET: Peter Murphy first opened his market at 39 West Main Street in 1886. By 1936 his business had grown and he moved his grocery down the street to a larger facility at 48-50 West Main Street. To celebrate fifty years in the business he wanted to reward one lucky customer with a brand-new, $872 Dodge Deluxe Sedan outfitted with Pharis Tires. The business operated at this location until 1950.

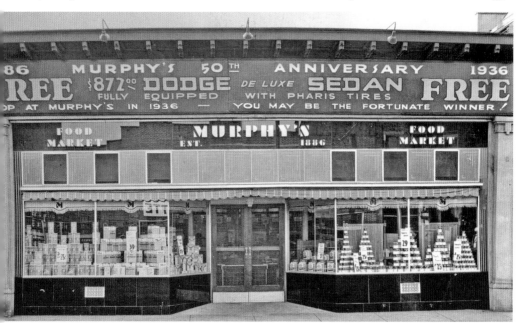

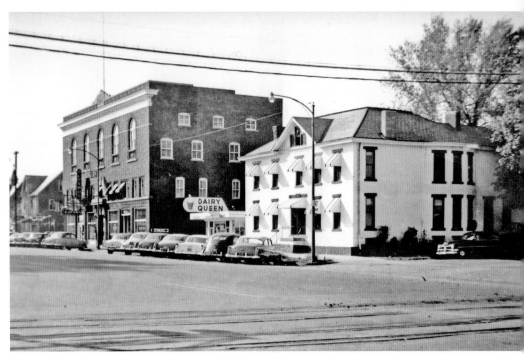

FROM KNIGHTS TO KUNG FU: The Knights of Pythias – a fraternal organization and secret society – was founded in 1864. Their building on East Main Street has been home to many organizations including the Dramatic Order of Khorassan, the Pythian Sisters Alberta, Order of Amaranth, Galilean Shrine and the Golden Rule Santha. It was even home to the A. P. Hess Automotive Company. In 2014 Impact Family Martial Arts offers fitness training for the entire family.

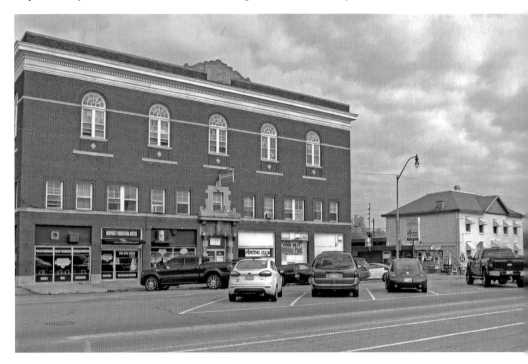

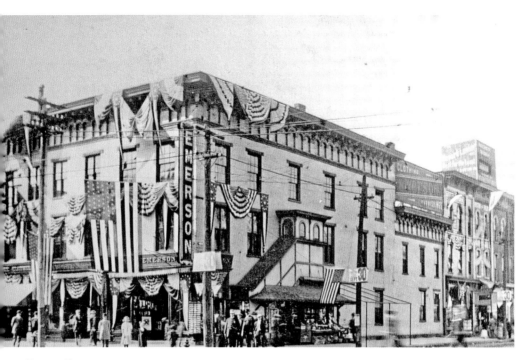

PRIME LOCATION: In the late 1880s if you needed clothing, hats, or furnishings you went to Emersons on the corner of West Main and Third. Emerson Roe established his business after buying out the stock of the Buffalo Clothing Store. In 2014 it is the Earth Works Recording Studio owned by Tom Atha. To the west is the Draft House owned by Eula Rizzo since the 1970s. It is the home of the famous Benjy-Boy-Girl sandwich.

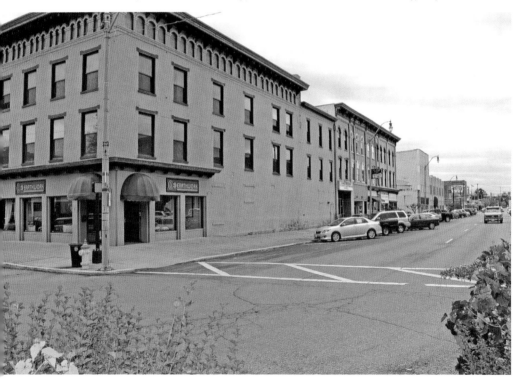

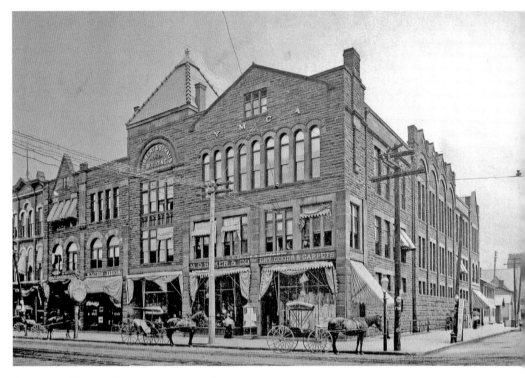

ANOTHER BLOCK DESTROYED AND REBUILT: In 1818 the Black Horse Tavern, a livery stable, and a stock yard was located on the northeast side of the square. And before the Hibbert and Schaus Building was built, a coal company sat there. The block was devastated by fire in 1971 when the kitchen of the Carousel Restaurant burned. The block is occupied by the new and modern building of the First Federal Savings and Loan in the 2010s.

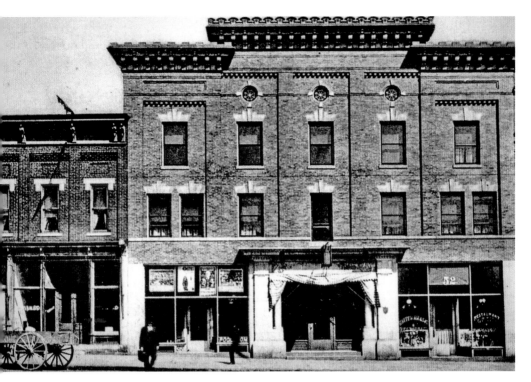

HOTEL ROW: South Second Street was once home to a myriad of hotels. For a hundred years there seemed to be at least one hotel on this stretch of street. In the late 1800s there was the Germanic Hotel and the Travelers Home. In the early 1900s, the Merchants Exchange Hotel, Hotel Newark, Hotel Seiler, and the Star European Hotel – shown here around 1911. The former building is home to the Licking County Art Gallery and the Grill Works Deli in 2014.

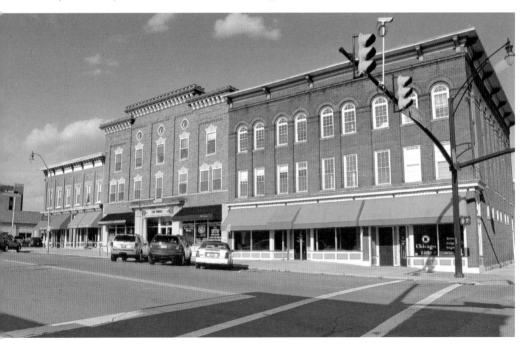

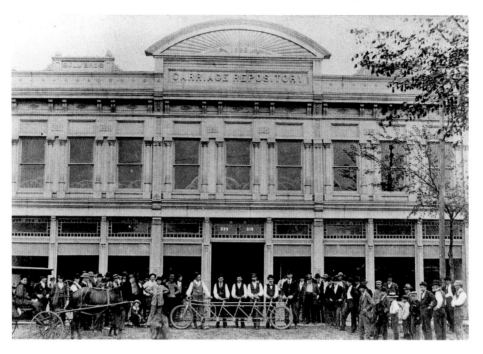

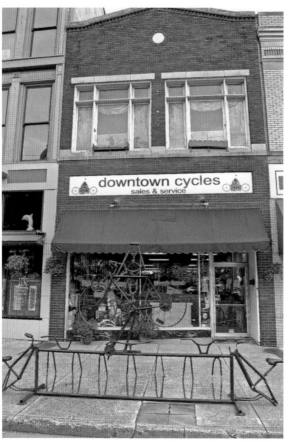

TRANSPORTATION: Bicycles and carriages were a fashionable form of transportation in the early twentieth century. This carriage repository was located between Church and Locust Streets on First Street. During the early 1900s there were three carriage manufacturers, one carriage painter, and one carriage dealer in Newark. Carriages are no longer in vogue, but bicycle riding remains an admired pastime. In 2013 Cody Clary and Justin Wood opened Downtown Cycles Sales and Service on North Third Street for the riding enthusiasts.

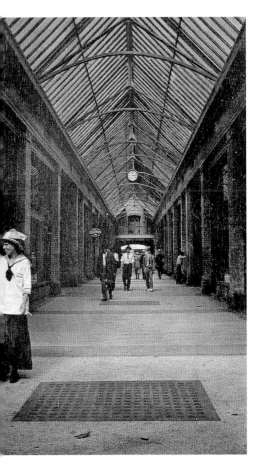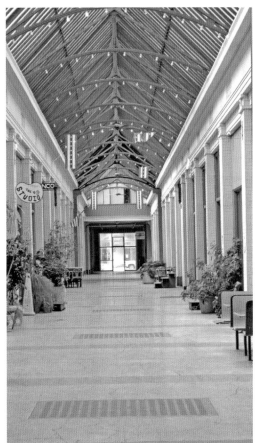

THE ARCADE: The Arcade Realty Company began construction on this glass-roofed structure in 1907, on the site that was once occupied by livery stables, dilapidated sheds, and deteriorating buildings. Stretching a block long, this unique structure once held over thirty shops and eight upper-level apartments. After years of tremendous success some of the businesses closed but others remain and are thriving. (*Courtesy of Virginia Beach.*)

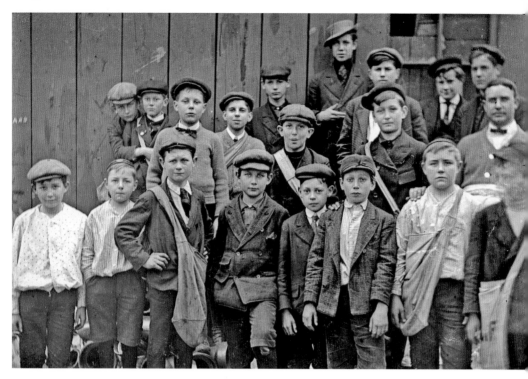

THE ADVOCATE: The newspaper's first edition came out in 1820 when twenty-two-year-old editor Benjamin Briggs first put type to paper. With only 450 residents in the city at that time, news traveled fast and a daily newspaper wasn't necessary to receive the latest gossip. In the 1920s young boys sold the papers on street corners to passers-by. In 2014, it is recognized as the oldest business in the city and occupies this modern building on North First Street.

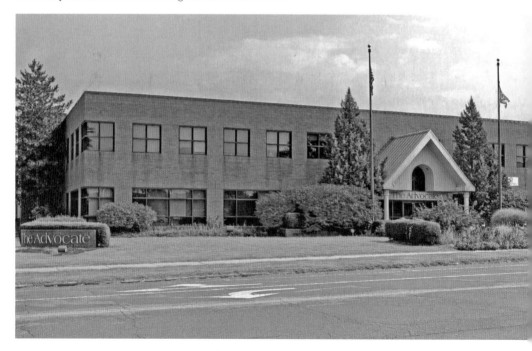

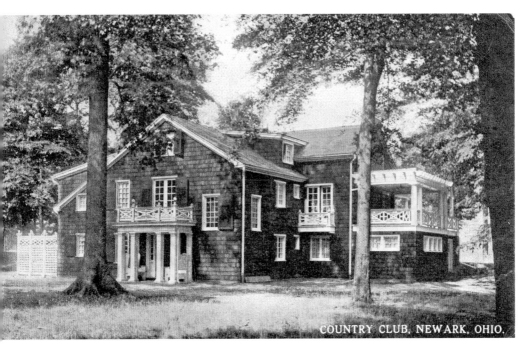

COUNTRY CLUB, NEWARK, OHIO.

MOUNDBUILDERS COUNTRY CLUB: The organizational meeting for the new club was held May 17, 1900. They chose the Taylor Farm, about one mile east of Newark, on grounds that held an army encampment and the sacred mounds to the Hopewell people. The club replaced the old wooden structure with a beautiful brick building that now welcomes its members and guests. The private club is open several times a year to the public to view and visit the hallowed site.

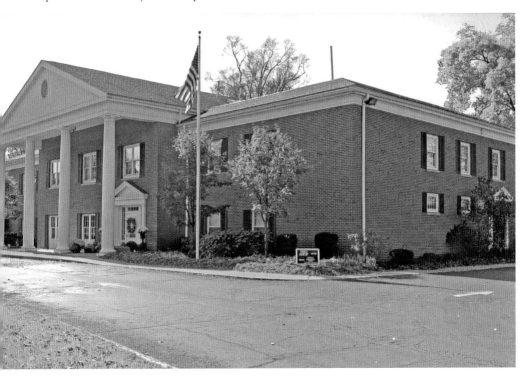

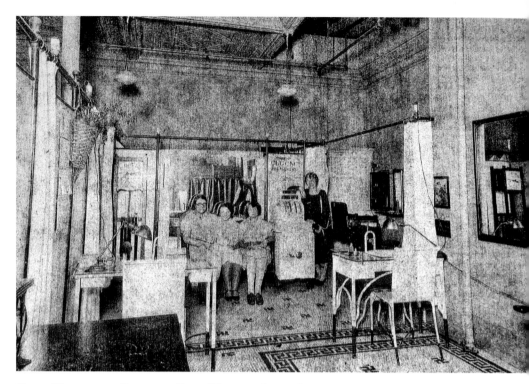

GIRLS WANT TO BE PRETTY – GUYS WANT TO LOOK GREAT: Since the early 1900s women have gone to the "beauty shop" for a new hair-do. In the mid-1900s many would go to McDonalds Beauty Shop in the Arcade for the newest cut and curl. Since the mid-twentieth century many ladies and gentlemen have visited the Small and Smart Beauty Salon on South Third Street. Hairdressers Violet Merritt, left, and daughter Donetta Kirk pose in from of their popular shop.

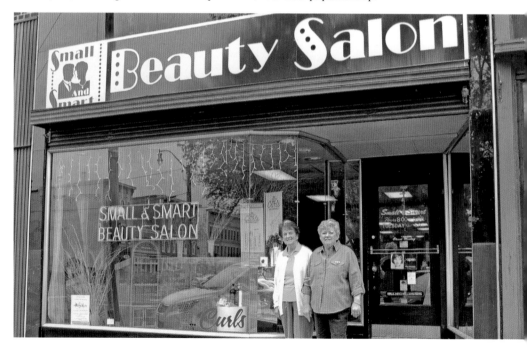

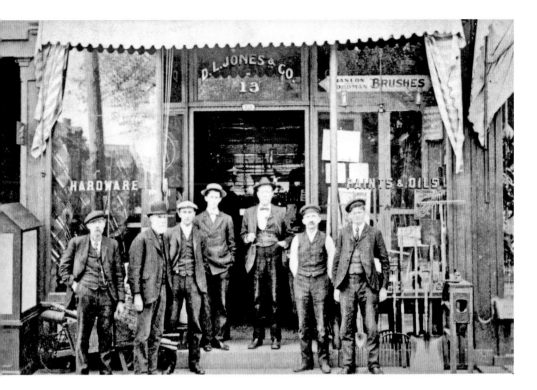

THE SOUTHWEST SIDE OF THE
SQUARE: The Daniel L. Jones and
Company hardware store was located at
13 South Third Street in the late 1800s
and offered something for everyone.
Candlewick Commons now takes a
large portion of the block, in the early
twenty-first century. The high rise building
provides apartment living for downtown
residents. On the first floor of the building
is a McDonalds Restaurant.

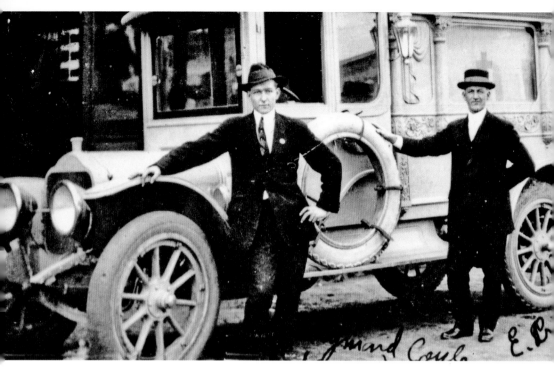

CRISS BROTHERS: Elijah Criss started his business in 1894. By 1902 he and his brother David had moved to a room east of the Warden Hotel. This is thought to be their first hearse. They were the first exclusive funeral home in Newark. The company has been located on South Third Street in the Sears, Roebuck and Company building, at 131 West Main Street, and now on Granville Street in 2014. It is known as the Criss-Wagner Hoskinson Funeral and Cremation Services.

INTERURBAN: The Jewett Car Company moved to Newark in 1900 and employed nearly 500 men. They manufactured all kinds of electric, interurban, elevated, and subway cars. These were shipped to all major cities across the country. They built steel cars for such cities as San Francisco and San Jose. In 1917 the company designed and built an ambulance and shipped it to France to aid in the war effort. Nearly a hundred years later a completely restored car sits at The Works Museum.

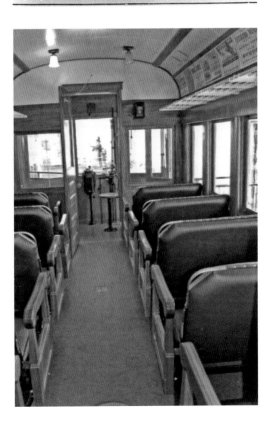

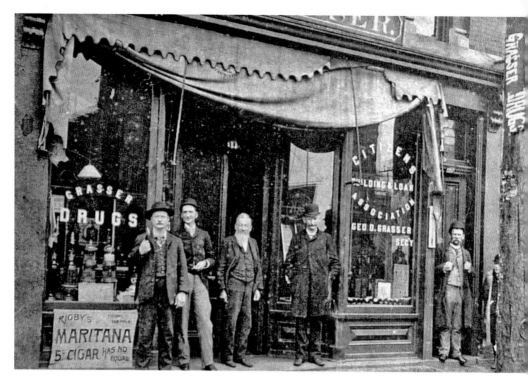

UPDATED ARCHITECTURE: Constructed around 1885 the building at 14 West Main Street held a drug store operated by George D. Grasser. He was also the Secretary of the Citizens' Association Building and Loan. The building's façade was altered in 1926 in the popular new art deco style for the new home of the Newark Savings and Loan Building Association. The Newark Coin Exchange LLC has been doing business in this handsome building since the 1980s.

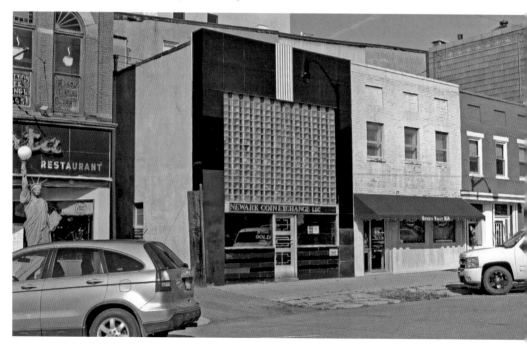

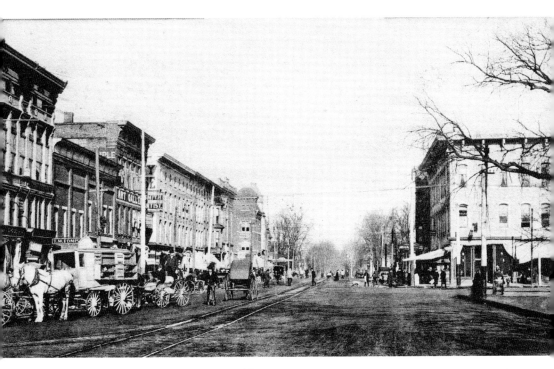

THE VIEW OF THIRD STREET, LOOKING NORTH: In 1910 horse-drawn wagons, loaded with goods, lined the street. The tracks of the interurban cars lead north up Hudson Avenue to the homes of doctors, attorneys, and city dignitaries. The tracks are now gone, but the Lansing Building and several buildings are still standing and accommodate the shops of successful business owners.

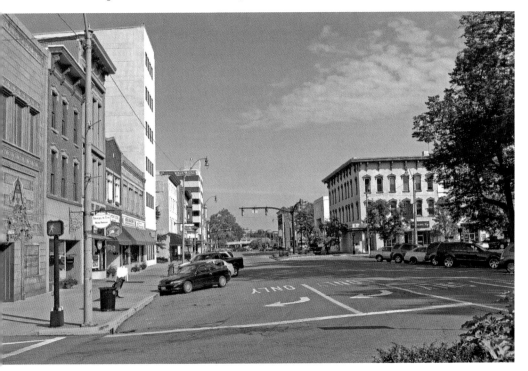

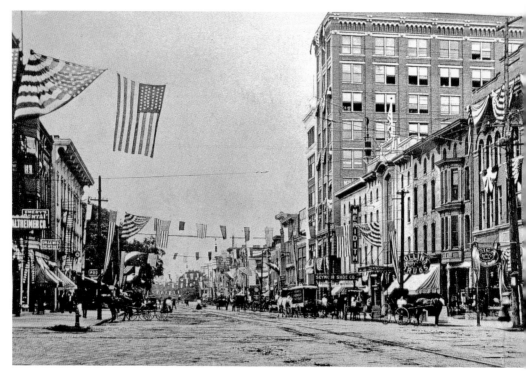

THE VIEW OF THIRD STREET, LOOKING SOUTH: In 1909 the city went all out to welcome the Grand Army of the Republic. The organization was founded to honor veterans of the Union Army, US Navy, Marines and Revenue Cutter Service who served in the Civil War. Flags and banners hung from every business in town. The streetscape hasn't changed much from that year. Newark still welcomes all veterans from military conflicts each year with a ceremony at Veterans Park.

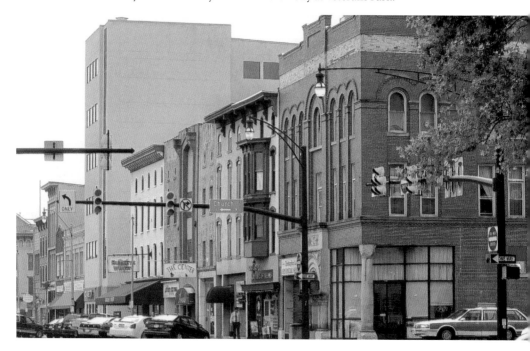

SUCCESSFUL SON: As a young man, George Allen Ball Jr. worked for his father in a haberdashery located at 17 South Park Place. Around 1892 the name changed to Ball and Son. Even though there is no record of any formal architectural training, Ball practiced his craft for over forty years and designed many homes around the city. In 1900 he married Edith May Sroufe, and fifty years later they celebrated their anniversary at a party with family and friends.

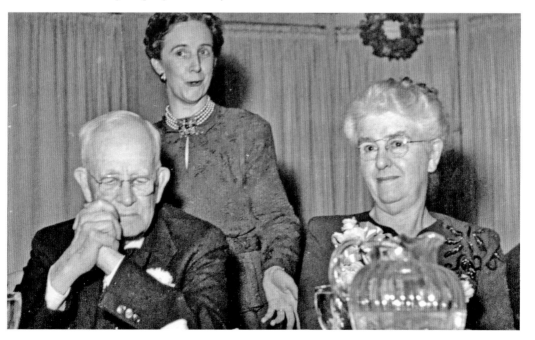

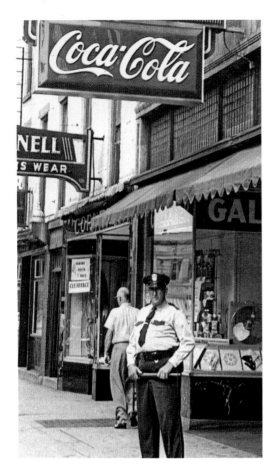
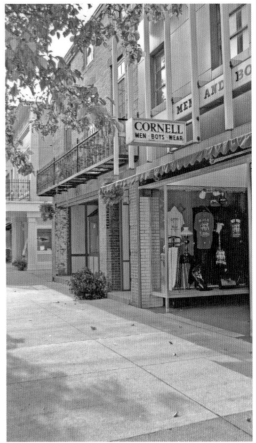

CORNELLS: First located on South Park Place, the men's wear shop relocated to the present facility on North Park Place around 1941. They were the first business in Ohio to sell "Levis" east of the Mississippi River. About 1950 Patrolman Dewey Hayes walked the beat to keep the streets safe but took time to pose for a photograph. The very successful clothing shop carries Boy Scout uniforms and quality clothing for men and women in 2014. (*Courtesy of Rebecca Dean Randall.*)

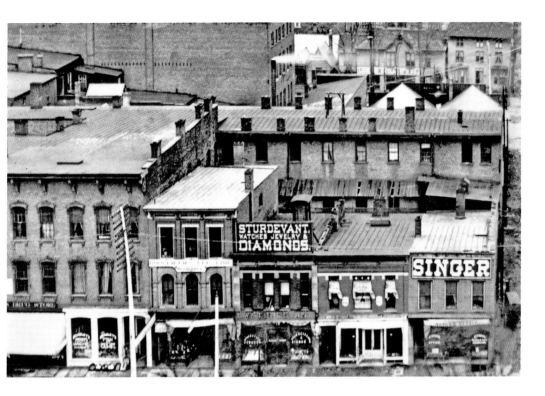

YOU CAN STILL BUY DIAMONDS: What a change. In 1885 the L. W. Sturdevant Jewelry Store was located at 16 North Park Place. The drab, uninteresting buildings have gone through a complete transformation. The façades of Matilda Charlotte Antiques Etc., H. L. Art Jewelers, and Goumas Candyland are now bright and welcoming in 2014.

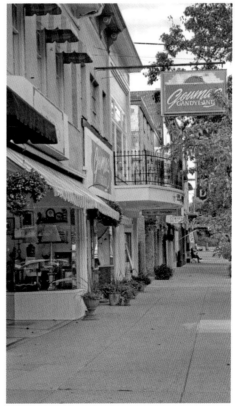

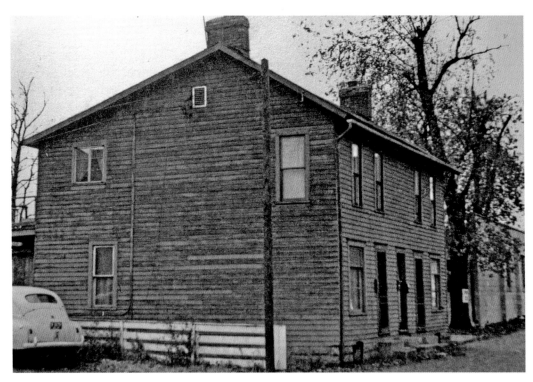

LOCK TENDER'S HOUSE: Legend tells of the old lock tender of Lock Number 9 sitting on his front stoop waiting for a boat to arrive. Long after the canal was drained, he would continue to sit alone and wait. The house has been restored and is owned by The Works Museum. At the recently unearthed lock, artist Curtis Goldstein recreated a scene from the early 1800s with a mural titled "House Boat on the Ohio Canal."

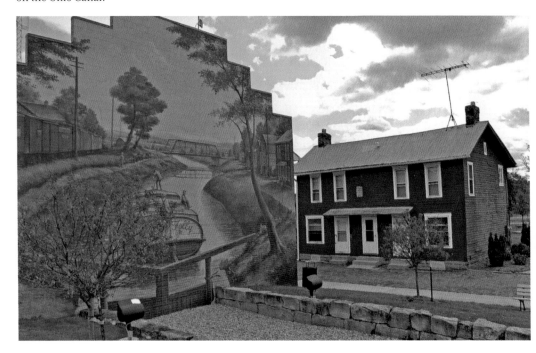

CHAPTER THREE

NEIGHBORHOODS

GARDENS: The more contemporary twenty-first century gardens of Licking County Master Gardener Kaye Alban were planted to attract bees and butterflies, but the flowers impress friends and neighbors. Her beautiful gardens have been the featured site for numerous garden tours, open to the public, and she is a regular speaker at seminars on deer-resistant plants and flowers that attract butterflies.

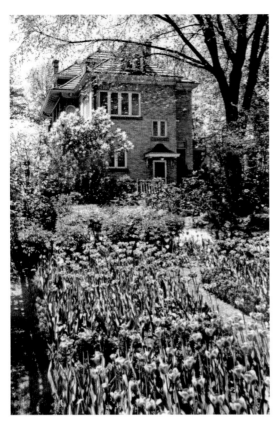

FORMAL GARDENS: The extensive gardens of the Weiant-Wehrle Home in the Hudson Avenue Historic District impressed Newark socialites in the early 1930s. Sculptures, urns, ponds, and flowers adorned the landscape and kept a full-time gardener employed and constantly busy. When Frank Webb wed lovely Shirley Pitser in 1907, he built her a home on Granville Street. The house is the Webb House Museum in 2014, and the gardens are as lovingly maintained as they were then. (*Courtesy of Terre Matthews.*)

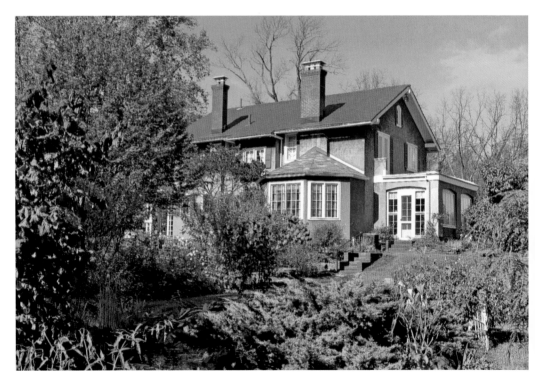

CITY HOSPITAL: After Mitchell Hospital – the city's first – closed on Hudson Avenue, the facility moved around the corner to this house on Wyoming Street. When that one became too small, a new and larger facility was built on Buena Vista Street. The top-ranking Licking County Hospital is located on West Main Street. In 1995 the Licking Memorial Health Professionals Corporation was formed to operate the program and in 2014 it has over 1,700 employee: of doctors, nurses, assistants, and administrative personnel.

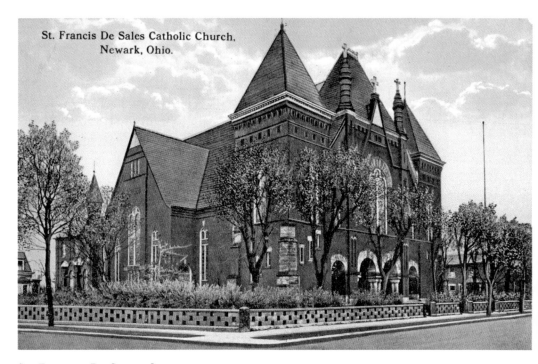

St. Francis De Sales Catholic Church,
Newark, Ohio.

ST. FRANCIS DE SALES CHURCH: In 1841 John McCarthy bought two acres of land on Granville Street. The next year the property was transferred to Bishop Purcell for a Catholic church. A small church was built in honor of St Francis De Sales. A second building was built in 1854, and by 1887, with over 2,000 parishioners, the need for a third church led to another one being built. In 2014 the congregation is still vibrant and growing.

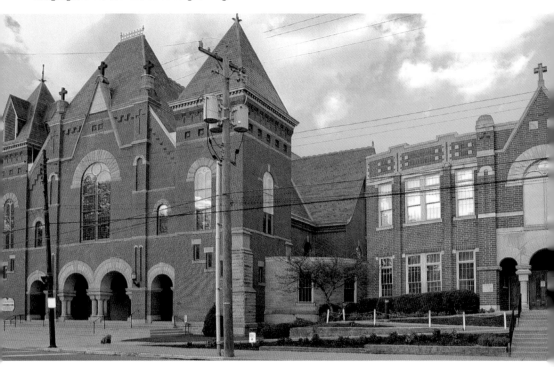

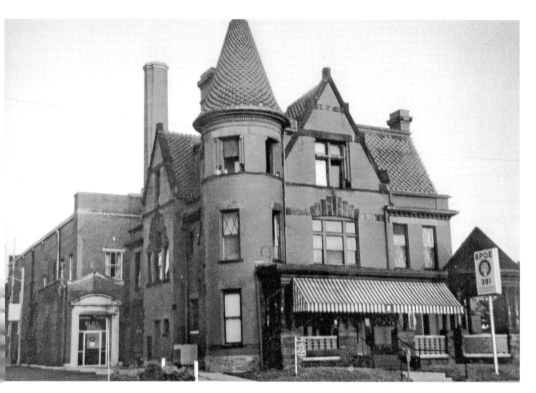

REPURPOSED MANSION: The magnificent home of the cigar manufacturer John Swisher – brother of Harry, industrialist, and co-founder of the Swisher Cigar Company – was built in the French Second Empire-style around 1899. The statement-making mansion was the largest house located in the downtown area. Around 1939 the Benevolent and Protective Order of Elks obtained the house for their Lodge Number 391. It was remodeled again to a more modern style. (*Courtesy of David Phillips.*)

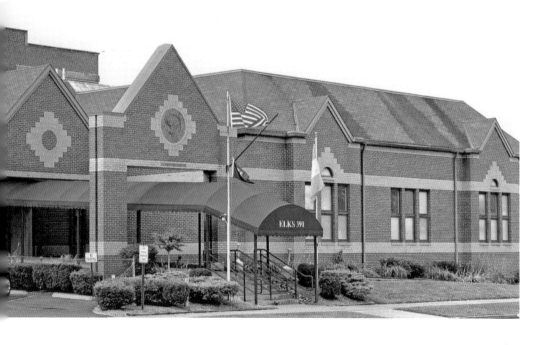

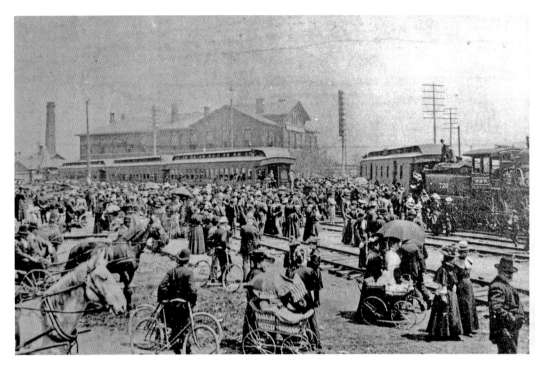

PENNSYLVANIA STATION: From the 1850s to the 1970s this railroad depot welcomed the military home from wars, and numerous US Presidents to our fair city, including Andrew Johnson, William H. Harrison, John Q. Adams, and President-Elect Abraham Lincoln. The depot experienced the hustle-bustle lifestyle of the late 1880s. In 1997 the Licking County Foundation bought the building at a sheriff sale. After a one million dollar renovation the depot is now home to several philanthropic organizations.

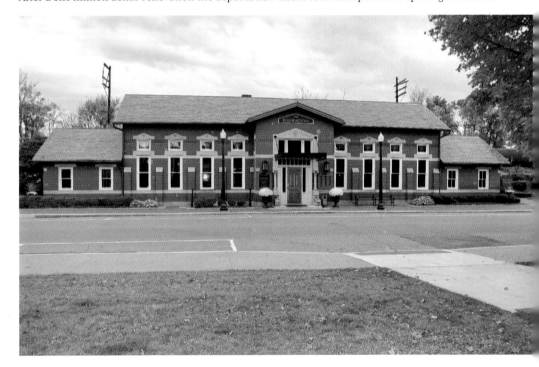

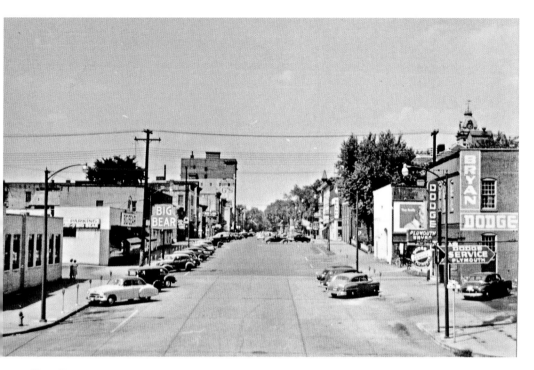

TWO BEARS: The small neighborhood grocery is a thing of the past. During the 1920s and 1930s, there were stores scattered everywhere around town. But years later most had moved away from the inner city. The Big Bear Store on South Third Street remained until the early 2010s. Aware of the fact that the only area grocery might vacate also, the owners of the Lil' Bear stepped up to provide a clean and efficient store that is vital to downtown residents.

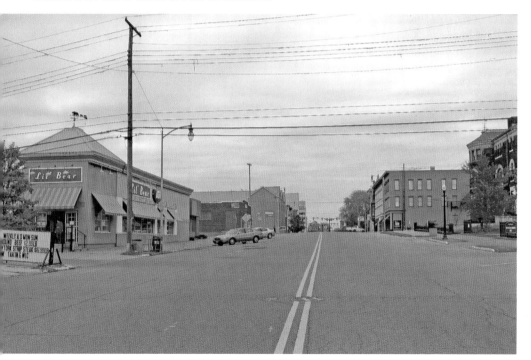

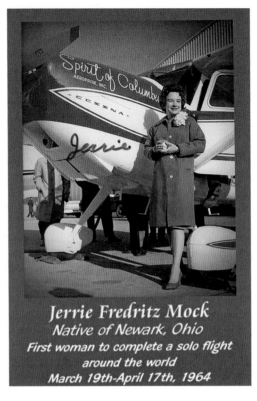

Jerrie Fredritz Mock
Native of Newark, Ohio
First woman to complete a solo flight
around the world
March 19th-April 17th, 1964

SOLO FLIGHT: Geraldine "Jerrie" Fredritz Mock was a world renowned aviatrix. She broke many world aviation records and became the first woman to fly solo around the world in a single-engine plane. Dubbed the "flying housewife," she flew her single-engine Cessna 180 "Spirit of Columbus" 23,000 miles in twenty-nine-plus days before landing in Ohio's capital city on April 17, 1964. The statue of Mock at The Works Museum in Newark was created by German Village Columbus artist Renate Burgyan Fackler and has Mock holding a book. A statue at Port Columbus Airport has Mock holding a globe with her flight path marked. She was the Columbus Hall of Fame's fifty-third inductee. Mock died on Sept. 30, 2014 at the age of eighty-eight. (*Courtesy of Susan Reid.*)

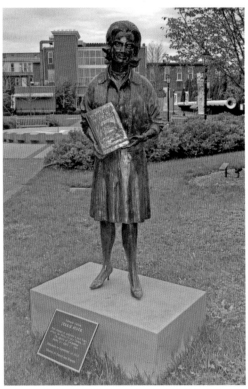

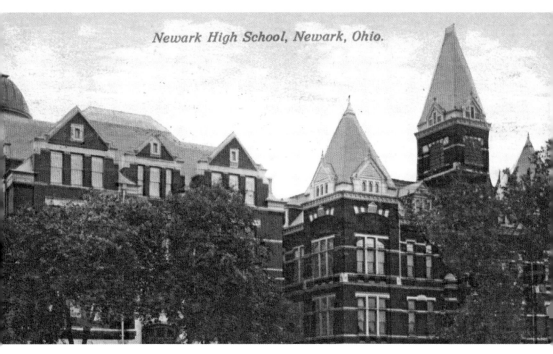

Newark High School, Newark, Ohio.

NEWARK HIGH SCHOOL: The city's dreams for a large high school were fulfilled with the dedication of the elegant structure on West Main Street in 1886. By the 1950s a larger facility was again required. The old school was razed in the 1960s. A larger, modern facility was built near Granville Street in a campus-style setting with seven classroom buildings with separate auditorium and gymnasium. After additional renovations, the school is under one roof in 2014. The ninety-plus members of the 2014 Newark Marching Band strut their stuff.

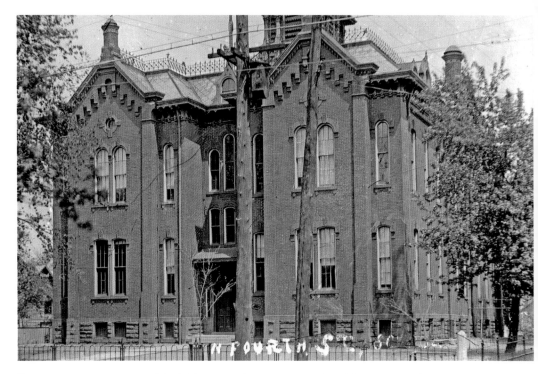

EDUCATION: In 1911 Newark had fifteen neighborhood school buildings, costing $514,000 with 111 teachers, educating over 4,000 pupils. It was written that "a diploma from any one of these schools would admit the holder to almost any American University without examination." The Fourth Street School was one of them. The Ohio State University founded a branch here in 1957 and began holding classes at Newark High School. The university branch is now a first-class establishment.

HOME OF THE MOUNDBUILDERS: The Hopewell people were hunters, gatherers, and agriculturalists. It is believed they constructed these large earthen mounds over two thousand years ago for religious purposes. The large geometric shaped structures at Newark include a circular mound and an octagonal mound. The new welcome center in the Newark Earthworks Park provides information to the thousands of yearly visitors.

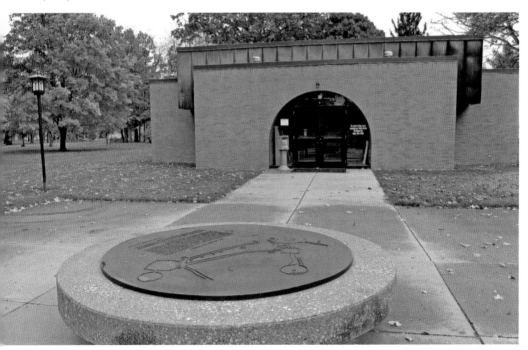

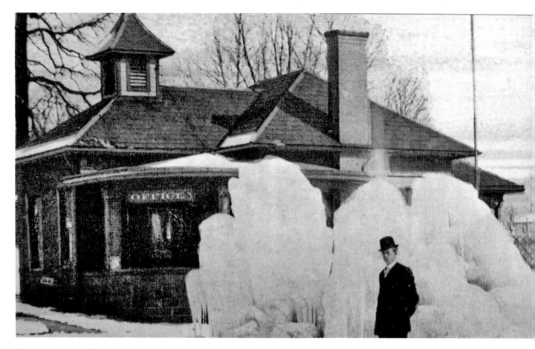

CEDAR HILL CEMETERY: To replace the old, overgrown, and neglected graveyard on Sixth Street a new cemetery was established in 1850 on the edge of town. The size has grown to 113 acres. Residents of this hallowed ground include heroes from all American military conflicts and two Medal of Honor recipients. In the winter of 1920 the water in the fountain was frozen with ice, and in the summer of 2014 the water sprays freely.

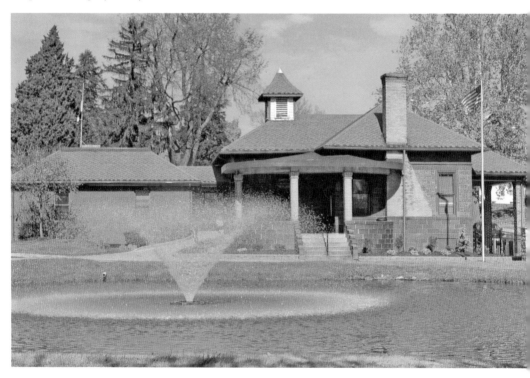

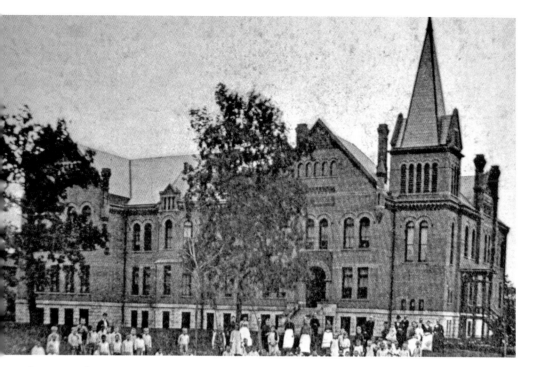

PUTTING CHILDREN FIRST: The design of the Old Children's Home won an award at the World's Columbian Exposition. Dedicated in 1888, it provided needy children a safe place to live until 1975. When the Foster Parent Program was established, the need for the old home diminished. The building was finally demolished in 2013. The Rotarians of Newark have now provided Rotary Park, a safe playground with interactive stations where children of all ages and physical disabilities can learn and interact.

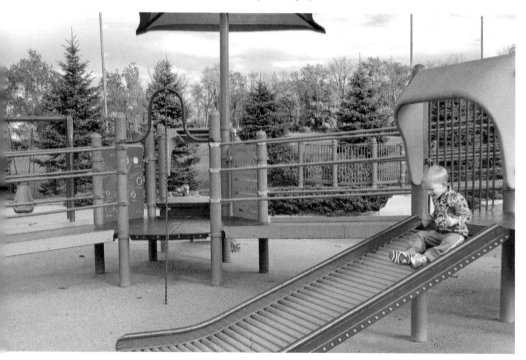

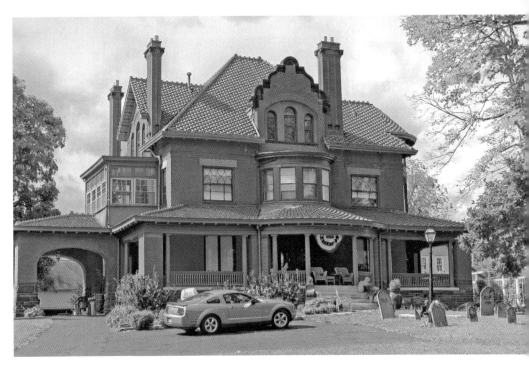

ARCHITECTURAL DIVERSITY: Newark welcomes diversity, not only in its people, but in their home styles. Every imaginable style can be seen. Cigar giant Harry Swisher chose a brick eclectic-style mansion to rival his brother's house downtown. As well, one can also find homes of poured concrete – an idea that came from Thomas Edison; Sears Homes, which could be purchased from their catalog in the early 1900s; and Lustron homes (pictured), of which only one or two out of the 2,680 built between 1949 and 1950 can be found in Newark. The plain porcelain steel structure featured all modern amenities including dishwashers.

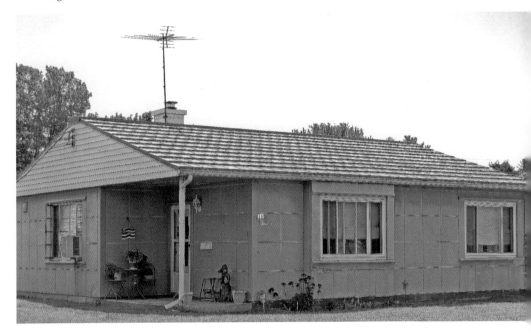

THE MCCUNE-STIMSON HOUSE:
An Italianate, brick, "Villa" beauty was
built in 1869 by merchant Dixon Brown
and given as a wedding present to his
daughter, the new bride of Civil War
Captain John McCune. From 1879 to
1893 the house was occupied by banker
Mehille O. Baker. The third occupant
was Dr. Claude Stimson, a surgeon at the
Newark Medical Hospital. He lived there
until 1945. The restored house is used as
offices in 2014.

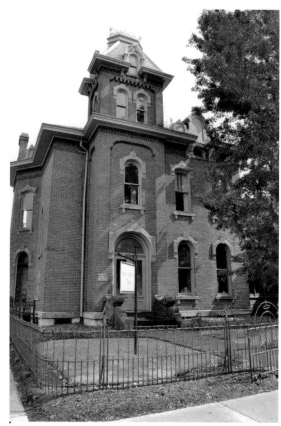

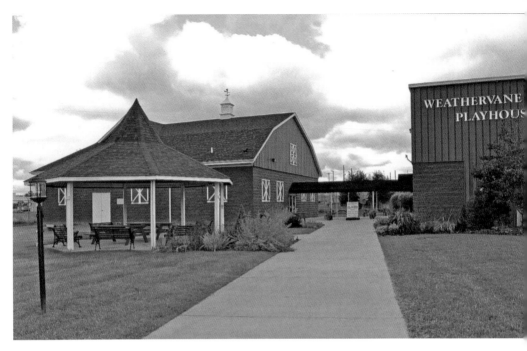

LOCAL COMMUNITY THEATERS: Newark is fortunate to have two excellent theatrical groups. The Weathervane Playhouse began in a barn in 1969. They now have a permanent home on Price Road. The Licking County Players began in a church in 1967. They too have their own permanent home on West Main Street. The Licking County Players advertised their up-coming shows for the 2007-2008 season during a local parade.

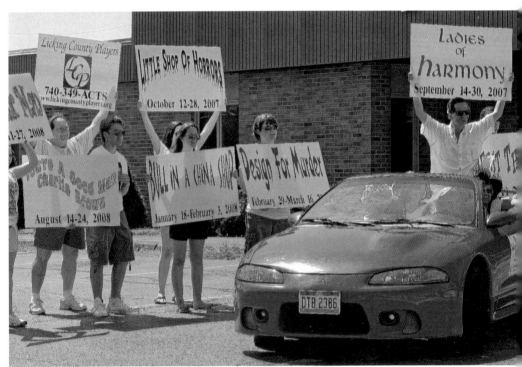

THE AVALON BUILDING: This impressive structure was built in the late Second Empire style around 1899 to provide upper floor apartments and offices for professionals, and businessmen at the street level. Falling into disrepair by the 1950s, the property was purchased and rehabilitation began in 2003. Apartments now help fill the need for housing in the downtown district. The structure sits directly across the street from the construction of the new Licking County Library one hundred years later.

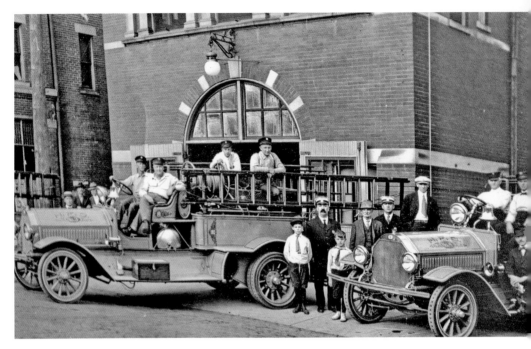

HOME TO FIREFIGHTING HEROES: The city has always had excellent fire protection. The fire trucks were parked in front of Newark's Police Patrol Station, located next to the Central Fire Station on North Fourth Street. In 2014 ground was broken on a larger, updated, and much-needed fire station on South Fourth Street to replace the smaller facility next door. When the building is finished the new station will once again be located next to the Newark Police Department.

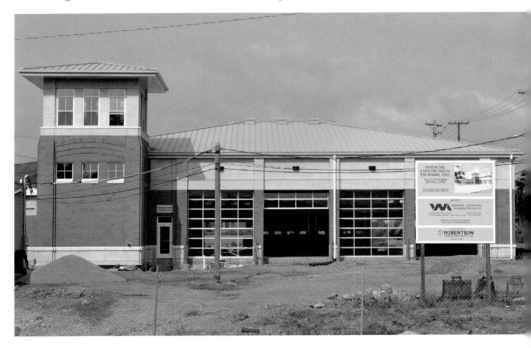

PUBLIC LIBRARIES: Once located at 88 West Church Street, the previous Newark Library outgrew its space after almost fifty years. The trustees purchased a site on the corner of West Main Street and South Fifth Street and broke ground on Halloween 1998. On Groundhog's Day in 2000 the larger and more efficient Licking County Library opened its doors to the public. At the entrance, a stone archway with a bronze sculpture entitled "Learning Curve" by sculptor Gary Lee Price welcomes visitors.

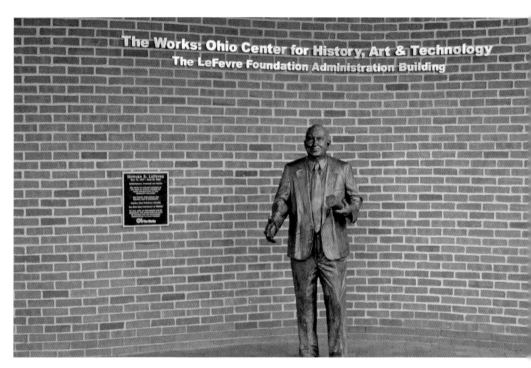

SUCCESSFUL BUSINESSMEN: Howard LeFever was the founder of the B&L Trucking Company. As a philanthropist and benefactor, he was instrumental in saving and restoring the Schidler Machine Works and making it a world-class Smithsonian affiliated museum. The Works Museum has honored him with a bronze statue. Another visionary man that is fulfilling his dreams is Jerry McClain. In 2014 he built this beautiful office building as a gateway into downtown Newark.

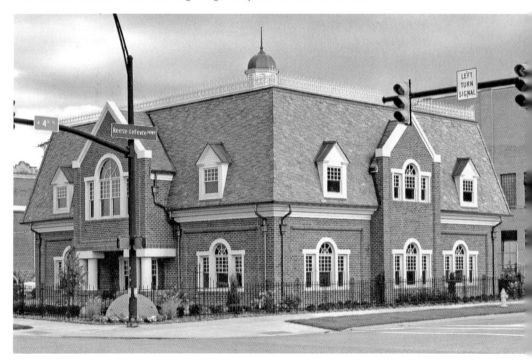

Chapter Four

People and Events

CLARENCE WHITE: After moving to Newark in 1887, White attended the Columbia Exposition in Chicago in 1893, and became interested in photography. In 1906 he moved from this house on Hudson Avenue to New York City and established the Clarence H. White School of Photography. He is known as a world-class photographer. The house remains.

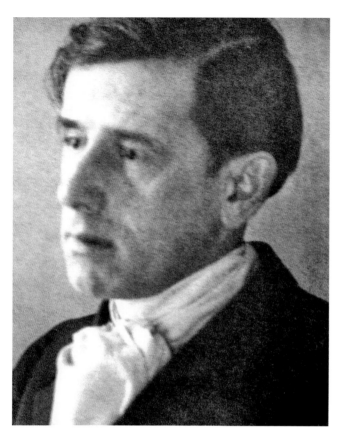

PHOTOGRAPHERS: Clarence White lectured at Columbia University Teachers College and is a recognized leader in artistic photography. He died suddenly in Mexico on a field trip with students. In 2002 Elizabeth and Timothy Argyle moved from Provo, Utah to open a studio in Newark. Their thriving business on South Third offers the latest trends in classic portraiture.

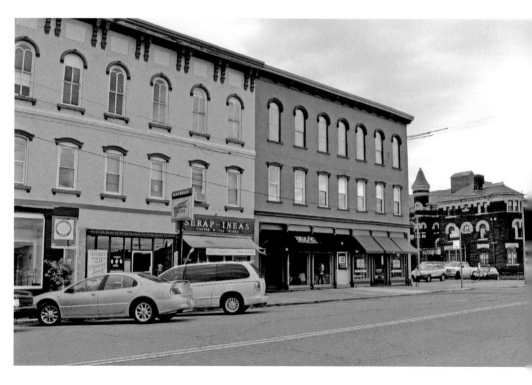

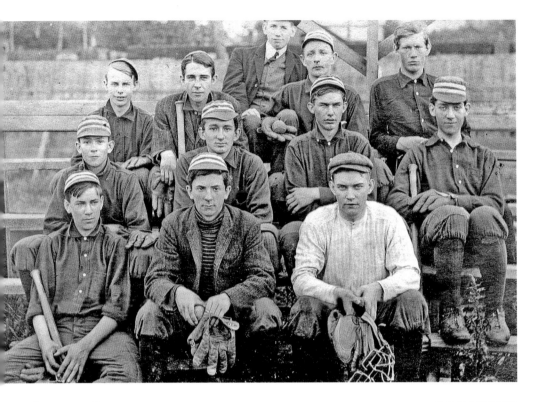

BASELL RULES: In the 1930s and 1940s local factories had ball teams competing with other companies. Many young players began at the local Don Edwards Field. It is home to a Frontier League team and has hosted the Babe Ruth eighteen-and-under World Series. Hometown hero Derek Holland pitches professionally for the Texas Rangers but returns home often to help his community. He appears as a role model for students at the local bowling alley photographed with Ely Rutter. (*Courtesy of Erin Rutter.*)

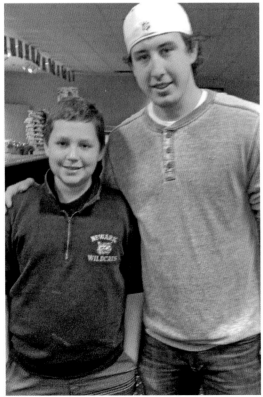

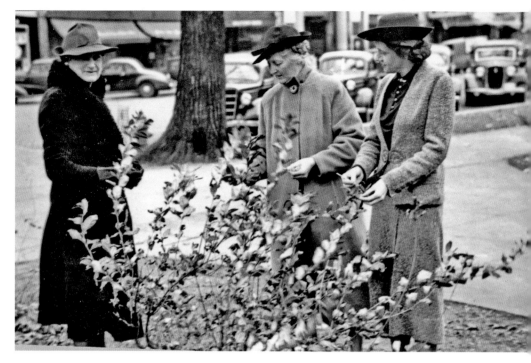

GARDENING ON THE SQUARE: In 1934 socialites, from left to right, Margaret Fitzgibbon, Mrs. J. Park Shai and Laura Beggs – members of the Newark Garden Club – inspect the rose bushes on the courthouse lawn. Landscaping the Square was part of their beautification project. In 2014 the local Kiwanis Club did their part to beautify the downtown by planting summer flowers in one of the islands located at the intersections. They maintained the flower bed for the entire growing season.

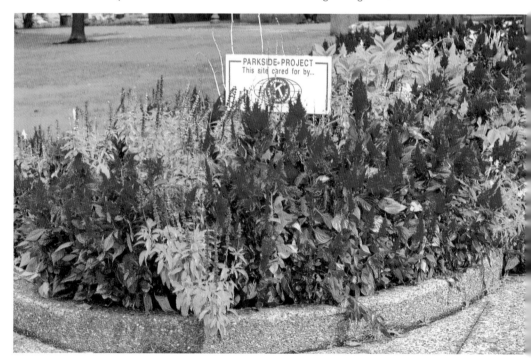

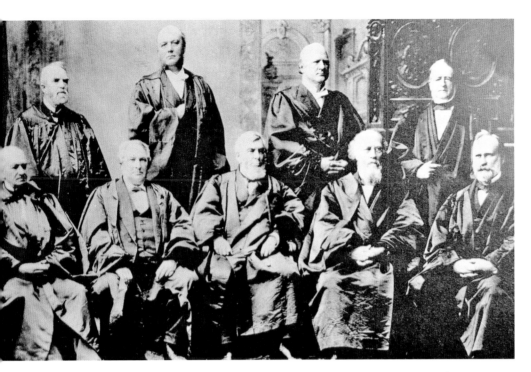

JUSTICES: Top row left: Major General William Burnham Woods, attorney and Civil War veteran, rose to acclaim as a Supreme Court justice. In 1997 the judges of the Licking County Court of Common Pleas pose after being sworn in office. Top left to right: Judge Steiner, Judge Marcelain, Judge Higgins, Judge Moore, Judge Laughlin, and Judge Hoover. Bottom left to right: Judge Frost, Chief Justice Moyer, and Judge Spahr.

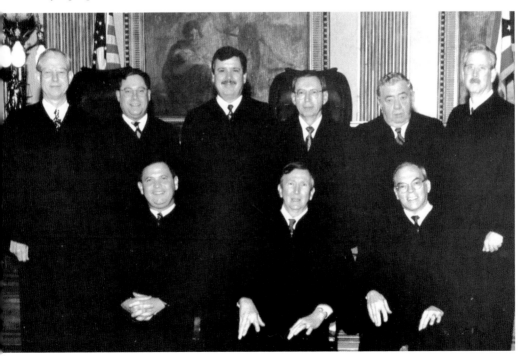

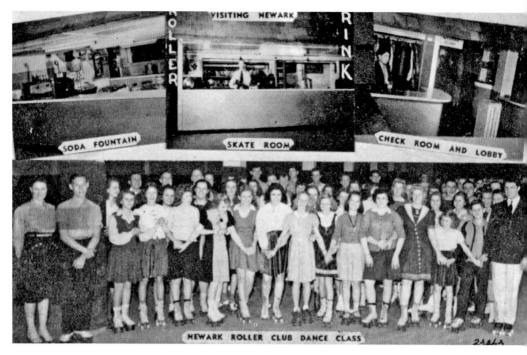

VISITING NEWARK ROLLER RINK

SODA FOUNTAIN

SKATE ROOM

CHECK ROOM AND LOBBY

NEWARK ROLLER CLUB DANCE CLASS

A ROLLING GOOD TIME: Ever since teenagers first put on roller skates, they have loved to congregate with friends for an evening of music, skating and snack food. The roller rink located at 68 East Main Street had the latest amenities with a dustless floor and skate servicing machinery. The rink featured professional instruction in dance and figure skating. The Roll-A-Way Center located on Church Street is celebrating sixty years in business in 2014. In 2010 a group of young ladies enjoy skating just as the ones in the 1950s did.

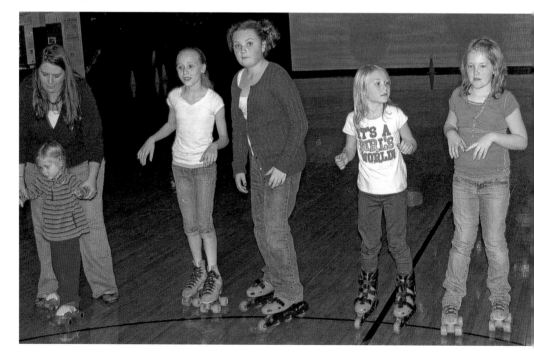

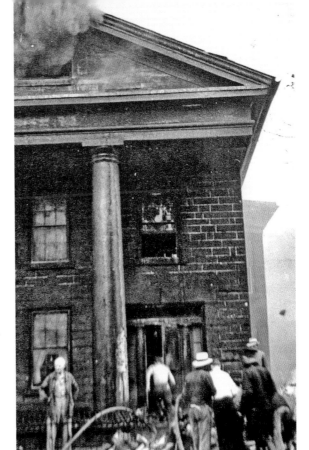

DEVASTATION: On September 8, 1943 an Army B-25 bomber on a training flight from Dayton to New York crashed into a neighborhood at the intersection of Hudson Avenue and Wyoming Streets. All six personnel on board plus two civilians on the ground were killed. Many others were injured and suffered burns. One home suffering damage was this Greek revival on the corner where it still majestically stands.

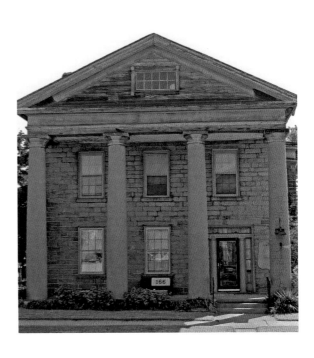

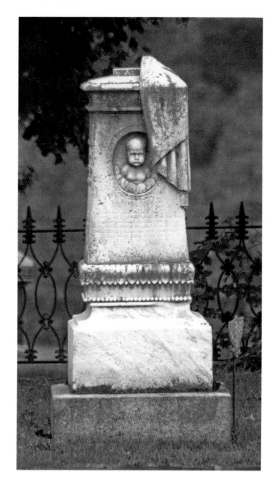
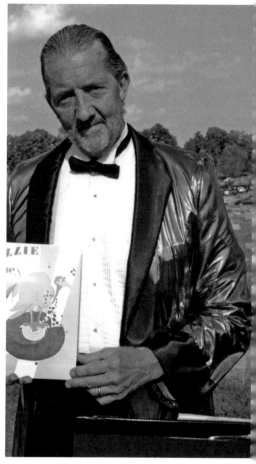

GRAVEYARD: In the oldest section of Cedar Hill Cemetery sits a large headstone with a carved three-dimensional image of a baby's face. People say, if you stare at the face – turn around – and look back, the baby will be looking in another direction. This is just one story you might hear when the Licking County Historic Society holds its popular annual graveyard walk, "Echoes of the Past." In 2014 local actor Robert McAleer portrayed Duke Nutter, music composer, musician, and author.

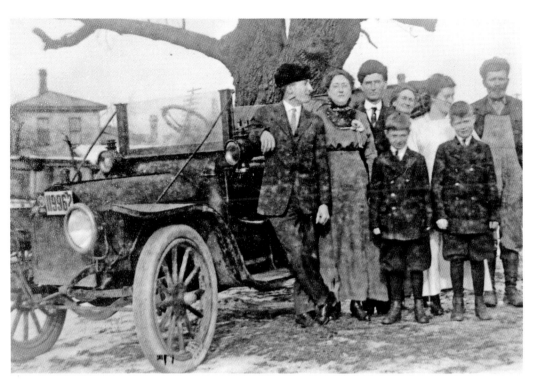

AUTOMOBILES: The residents of Newark love their vehicles. This unidentified family is posing beside their new set of wheels. Each year in September car aficionados from far and wide arrive in the public square with their pride-and-joys, for the annual "Lite the Night" car show. Money raised at this event goes to the cost of lighting the courthouse for the Christmas season. These are just a few of the hundreds of vintage cars lining the streets in 2014.

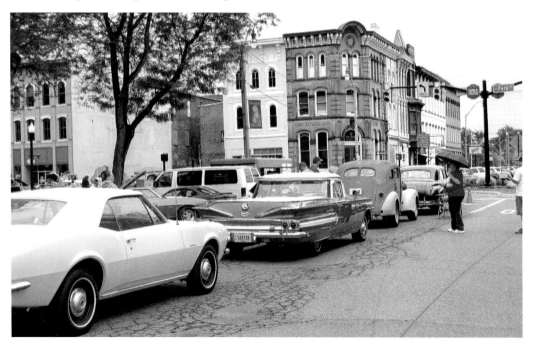

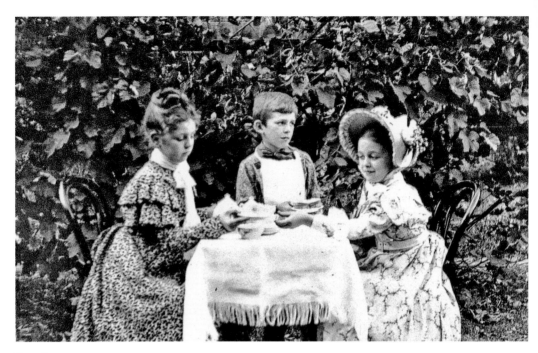

TEA PARTIES: In 1897 the children of Mr. and Mrs. Richard Collins – from left to right: Marjorie, Thomas and Francis – donned their fancy dress attire and had a tea party. On a lovely autumn day in 2014, the ladies of "Monday Talks" did the same. The organization began in the fall of 1882 when Mrs. Cornelia Davidson entertained fifteen or so friends for tea. They are now beginning 133 years of sharing "talks" and friendship.

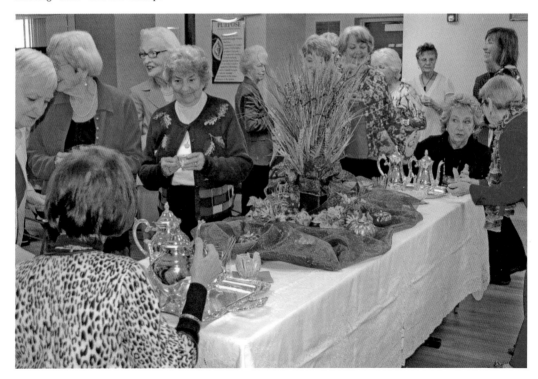

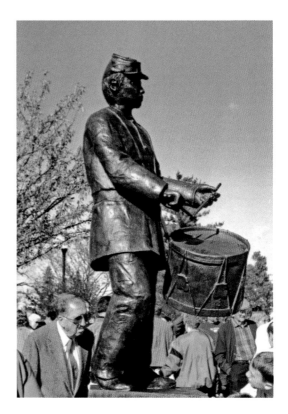

MAJOR GENERAL JOHN CLEM: Much has been written about Johnny Clem but it is believed he ran away from his home at the age of ten and joined the Union Army. On April 6, 1862 the lad of eleven marched into battle at Pittsburg Landing, Tennessee. He died in San Antonio at age eighty-six and is buried at Arlington National Cemetery. He has been immortalized in bronze by sculptor Mike Major and stands guard over the Sixth Street Veterans' Park.

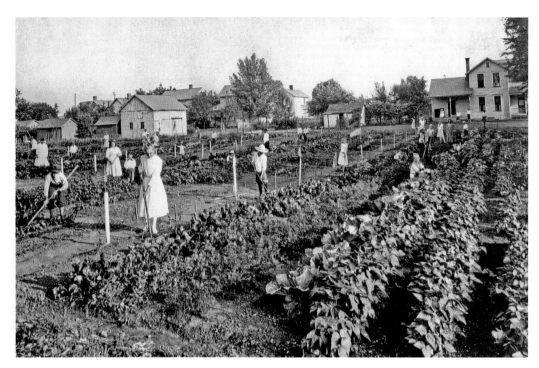

DIGGING IN THE DIRT: During WWI and WWII gardens were planted at private residences and public parks to help with the public's food supply. Indirectly aiding the war effort, they were considered morale boosters. Although no war effort was needed, the hard-working Licking County Master Gardeners planted and harvested over 3,000 pounds of veggies and then donated them to the local Salvation Army in 2014. Each year they show off their demonstration gardens with an open house.

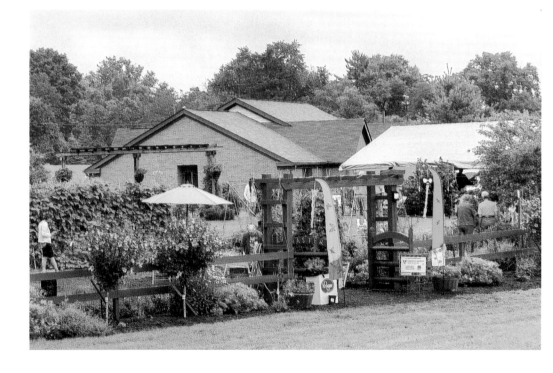

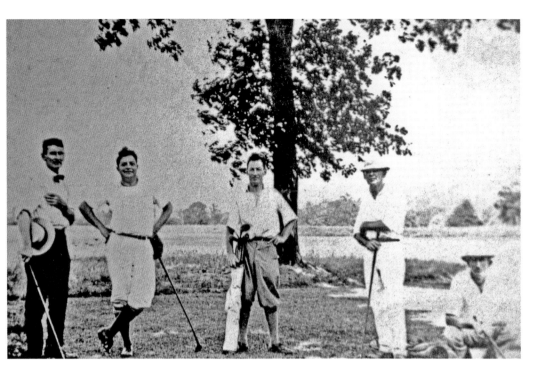

GOLFERS: These five dapper golfers – from left to right: Harry Scott, Clarence Heisey, Mac Baker, Dick Collins, and Ralph Wyeth – enjoyed a round of golf on the Moundbuilders Country Club course around 1900. In 2014, still dapper and still enjoying the game, these golfers love to drive, chip, and putt on the same course. (*Courtesy of Terry Mooney.*)

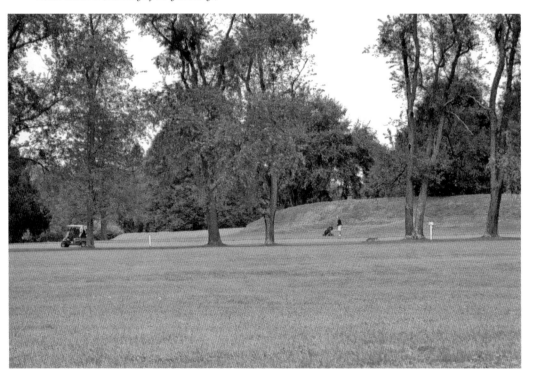

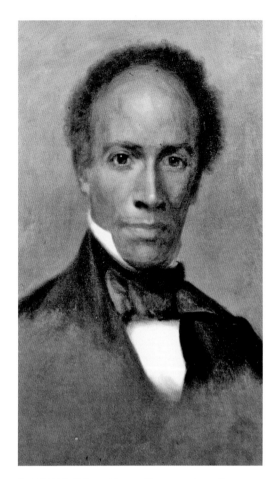
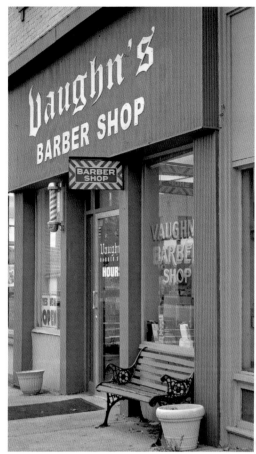

BARBERS: Edward James Roye was born to a prosperous family in 1815 in a small house on Mount Vernon Road. He attended Ohio University before establishing a barber shop in Illinois. In 1846 he immigrated to Liberia and pursued politics. After being elected the fifth president of the country, he was later deposed. In 1872 he died in Monrovia Harbor. Other successful Newark barbers, Roy and John Vaughn, began their very popular business on North Fourth Street in 1977.

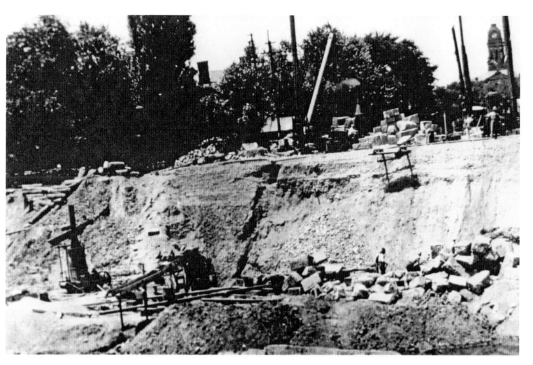

EAST MAIN STREET BRIDGE: Construction of a new metal structure crossing the Licking River on East Main Street began in the 1850s. The Massillon Company erected the bridge in 1858, replacing the old wooden-framed bridge. By 1909 the portrait of the bridge was showing up on postcards. Around 1997 the bridge was completely redone, and period lights were added to give the appearance of the original. It now qualifies for the National Preservation Register.

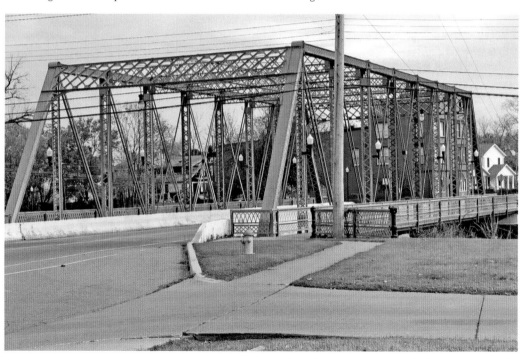

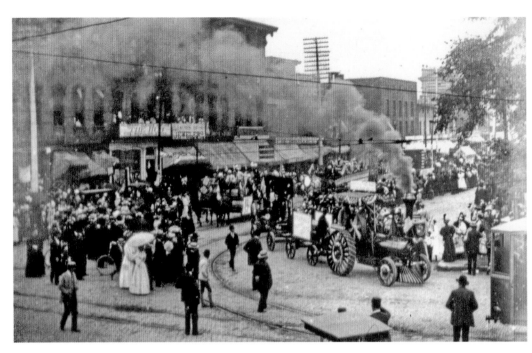

PARADES: Newark has always loved gatherings. At the turn of the twentieth century hundreds came out to see the parade of smoking machines in front of the Lancing Block. In 2002 Licking County celebrated its Bicentennial and a four-hour parade was held for the citizens of the county. Thousands of viewers lined the street to see the popular Las Vegas celebrity, Wayne Newton, who returned home to be honored as the grand marshal.

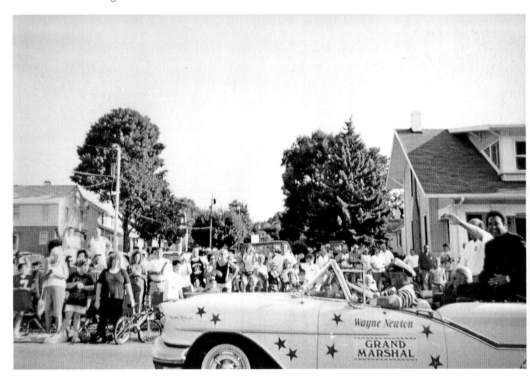

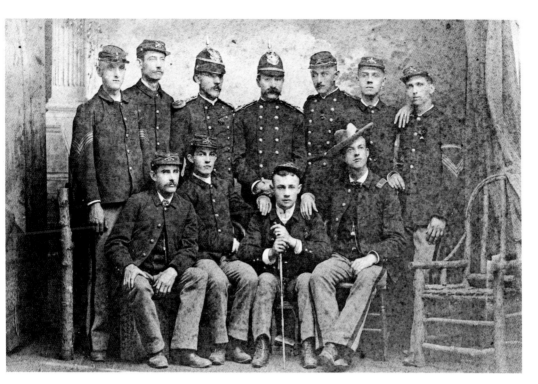

OHIO NATIONAL GUARD: In 1892 the 17th Regiment, Company G, pose in full military regalia. During that time period there were 135 Ohio National Guard units in the state, with six from Licking County, plus two calvary units. In the late 1800s an armory was built at 159 West Main Street, the site of an old roller rink. In 1988 members of the 737th Maintenance Battalion are pictured, from left to right: Sgt Chris Lucas, SP4 Alicia Jarrell, SFC Clarence Rutter and CW2 Perry Jones.

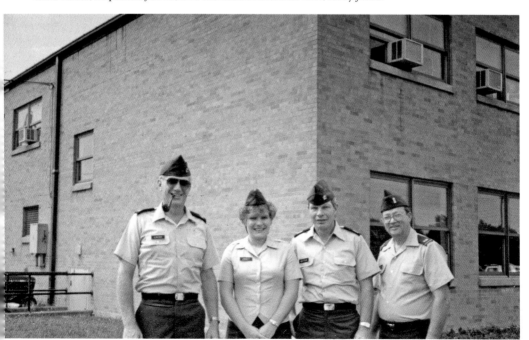

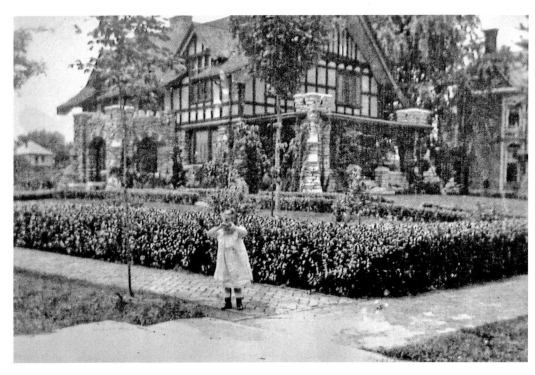

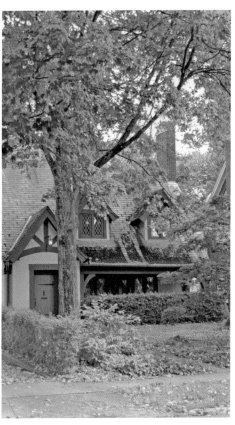

VIRGINIA'S ANCESTRAL HOME: At the age of four, little Virginia wasn't permitted to cross the street by herself. She lived with her parents, William and Alice (Fleek) Miller, in this 1902 magnificent home designed by renowned architect Frank Packer. She finally made it across when she married Harold Smucker and had this cottage-style home built, designed by local architect George Ball Jr. As an adult she became a math professor and a chemist. (*Courtesy of Walter Hinger.*)

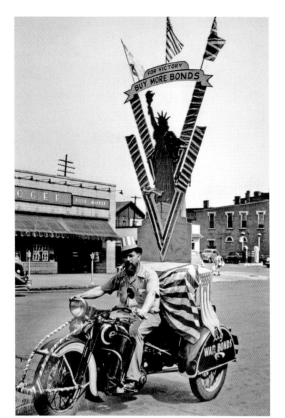

VETS: A motorcyclist promoting War Bonds cruises down South Second Street in 1943. All veterans are now welcome in the Licking County Veterans Memorial and Education Center. Over 880 servicemen from Licking County have been killed in war. The county has given her best. The center took over twenty years of searching and two years of construction but now accepts and welcomes military memorabilia, stories, and history of the men and women that have served.

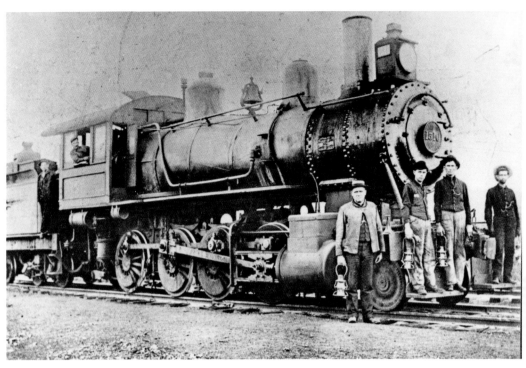

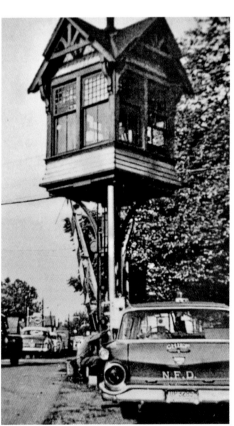

HARD-WORKING RAILROADERS: After the train system arrived in Newark in the mid-1800s, hundreds of men were needed to work on the tracks. Switchmen worked outside in all types of weather conditions. Whether it was in the snow and freezing cold or blistering heat they carried railroad lanterns to light the way. In the 1960s the men sat in a cozy guard house on East Main Street and warned motorists of approaching locomotives.

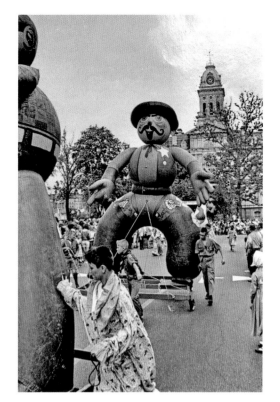

BIG BALLOONS: What can be more exciting at a parade than huge, colorful balloons? During the 1952 sesquicentennial parade the large balloons were a popular entry. In the summer of 2014 the "Squonk Opera Road Show" from Pittsburgh invaded the public square for an afternoon of zany music and madcap entertainment.

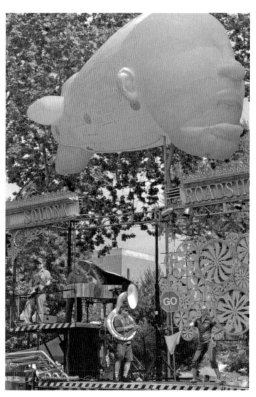

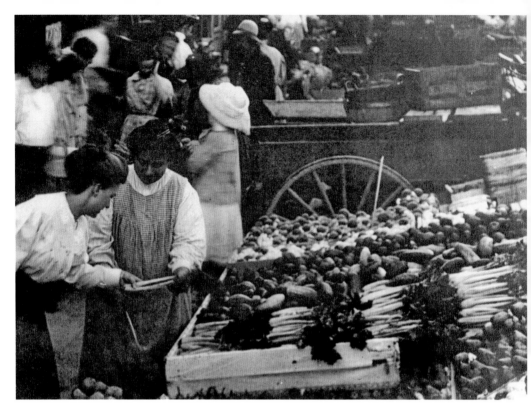

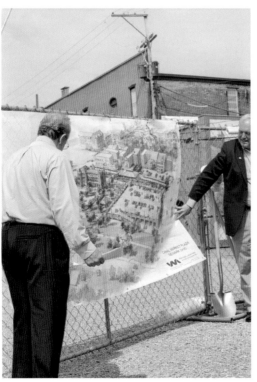

PUBLIC MARKETS: Ever since Newark became a city farmers have come to town to sell their excess fruits and vegetables. In the early 1900s produce was abundant and farmers made their way to the West Main Street Market with their bounty. In 2014, Mayor Jeff Hall (left) and County Commissioner Tim Bubb unveiled the elaborate plans for the new Canal-Market Plaza to be built where the canal waters once sat.

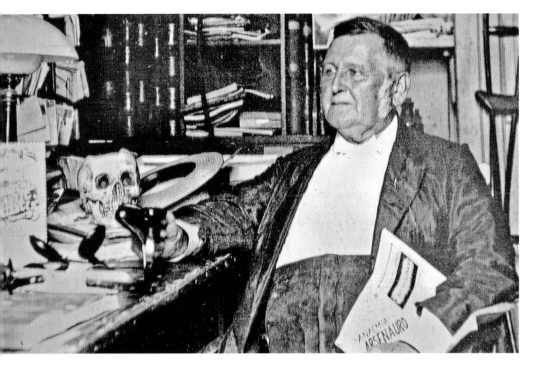

LOCAL PHARMACISTS: In the late 1800s the J. W. Collins and Sons Drug Store was located at 37 North Third Street. The office desk held an unusual accessory. A drug store in the downtown area was absent for many years before Arensburg's brought their friendly and efficient staff to West Main Street in 2010. Two doors west is a hardware store that has been a fixture in town for over sixty years as of 2014. Both bring a vital presence to the downtown residents.

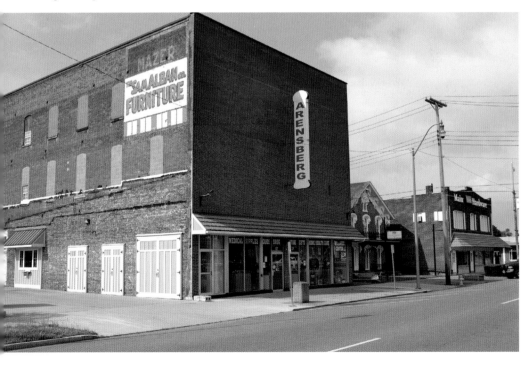

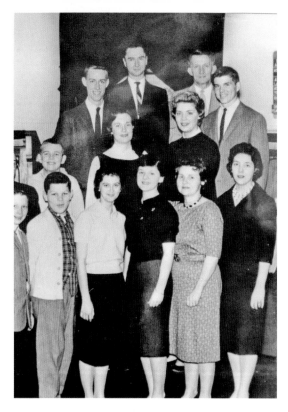

THEY DON'T COME ANY NICER: John Davidson, top right, the Pittsburgh-born singer and television personality was born in 1941, the son of a Baptist minister. After graduating from high school in White Plains, New York, he earned a degree in Theater Arts from Denison University in Granville. John took his naturally-gifted baritone voice to the musical stage. John sang with members of the Second Baptist Church located at 19 West National Drive. The church was organized in 1920. (*Courtesy of Marie Gartner.*)

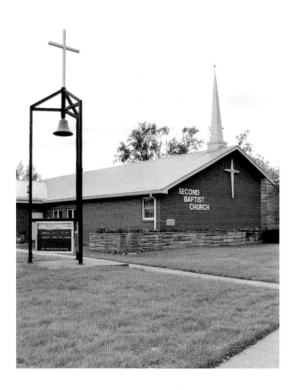